T0366931

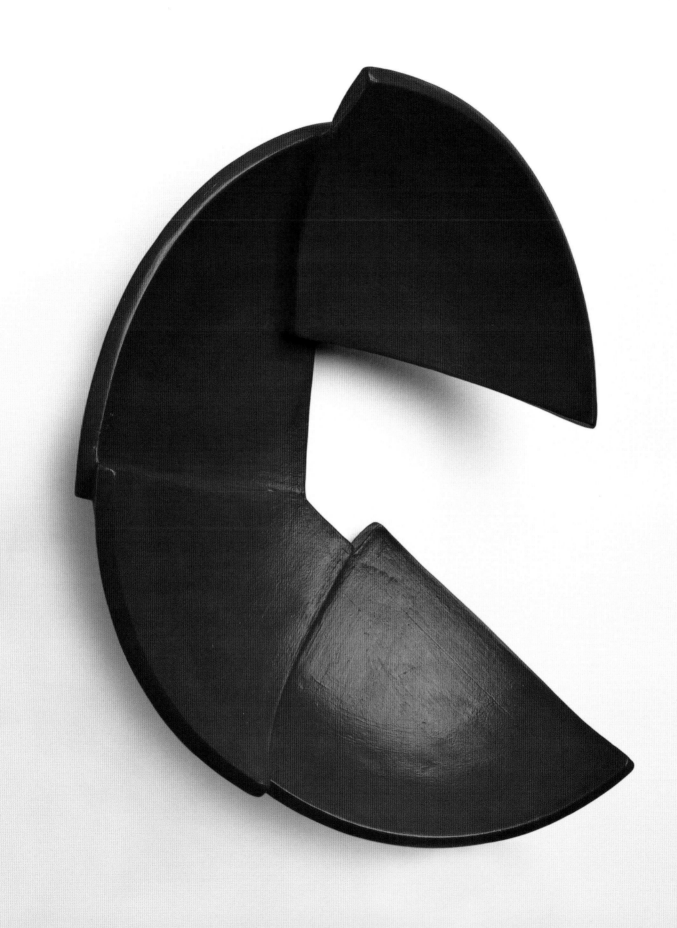

ESSAYS BY **JO LAURIA** & **JAKE SENIUK**

Anne Hirondelle
CERAMIC ART

UNIVERSITY OF WASHINGTON PRESS

SEATTLE & LONDON

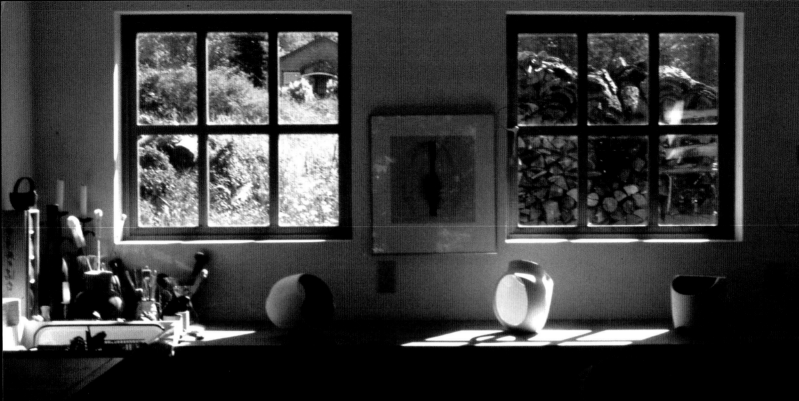

© 2012 BY THE UNIVERSITY OF WASHINGTON PRESS

17 15 14 13 12 5 4 3 2 1

UNIVERSITY OF WASHINGTON PRESS

PO Box 50096, Seattle, WA 98145, USA *www.washington.edu/uwpress*

LIBRARY OF CONGRESS CATALOGING-IN-PUBLICATION DATA

Hirondelle, Anne (Anne E.), 1944–

Anne Hirondelle : ceramic art / essays by Jo Lauria and Jake Seniuk. — 1st ed.

p. cm. — (The Thomas T. Wilson series)

ISBN 978-0-295-99151-1 (hardcover : alk. paper)

1. Hirondelle, Anne (Anne E.), 1944—Themes, motives.

I. Lauria, Jo. II. Seniuk, Jake. III. Title. IV. Title: Ceramic art.

NK4210.J499A4 2012

738.092—dc23 2011030221

Edited by Mary Coney and Pat Scott

Copyedited by Sigrid Asmus

Designed by Ashley Saleeba

Composed in Minion Pro and Whitney

Printed and bound in China

JACKET FRONT: *Re:Form 8*, 2010, painted stoneware, 6½ × 7¾ × 8¼ in., private collection. JACKET BACK: *Capo*, 1999, glazed stoneware, 21½ × 10 × 7 in., private collection.

FRONTISPIECE: *Measured*, 2008, painted stoneware, 11½ × 9½ × 4 in.; P. 2: *Untitled (red)*, 2007, painted stoneware, 11¾ × 13¼ × 4½ in.; P. 6: *Abouturn 28*, 2007, painted stoneware, 12½ × 12½ × 10 in.; p. 16: *Ibex*, 1991, glazed stoneware, 16 × 10 × 10 in., private collection; P. 66: *Remember Stack*, 2008, painted stoneware, cardboard, 32 × 11 × 11 in.; P. 78: *Tulip Vase*, 1996, glazed stoneware, H. 22 in. All courtesy of the artist and Francine Seders Gallery except where noted.

Images of Anne Hirondelle's studio in 1986 were originally published in *Ceramics Monthly* 34, no. 6 (June–August 1986): 34–39. Reproduced with permission. © The American Ceramic Society, www.ceramicsmonthly.org. Images of Anne Hirondelle's garden were originally published in *American Craft* 60, no. 6 (December 2000–January 2001): 60–63.

CONTENTS

Anne Hirondelle

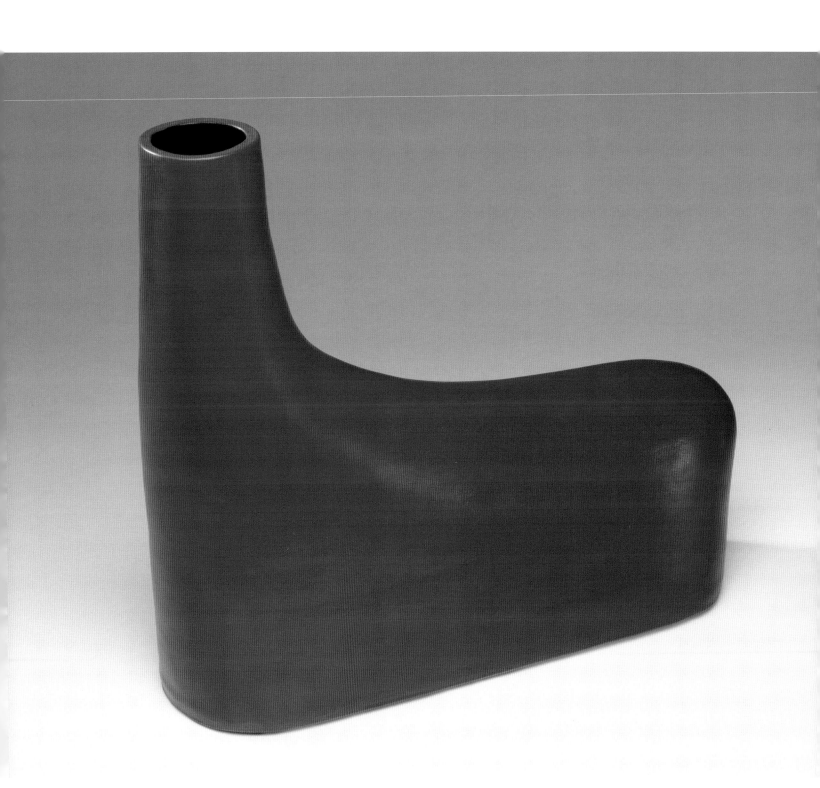

Mary Coney

THE THOMAS T. WILSON SERIES PAST, PRESENT, AND FUTURE

This is the fourth book in the Thomas T. Wilson series. When Tom's book was first conceived in Anne Gould Hauberg's living room, no one there had any idea where it would lead. Our modest goal was a small pamphlet of his portraits that could be shown to potential clients. It quickly became apparent that a larger record was required to capture Tom's artistic achievements. And so, some two years later in 2004—after others joined in the effort, meetings were held, paintings were chosen, writers were enlisted, a New York designer offered his talent, donors gave generously, and the University of Washington Press contributed its professional expertise—a book was published.

Its beauty surprised us all. And no one was ready to let go of the energy and enthusiasm engendered by the process (though that seems too deliberate a word to describe how this first book came into being).

Soon after, the second artist, Joe Goldberg, was selected, and another book was under way. We then discovered that, while the basic process was the same, this artist and his art presented different challenges. Many of Tom's paintings were very large, in different parts of the country, and held by some owners long out of touch with Tom. Joe's gleaming canvases were usually smaller but more delicate, as the wax process he uses (encaustic) makes his work sensitive to temperature changes and easily scratched. In both cases, getting their paintings to and from photographers was not an easy task. Whereas Tom's work had never been represented by a gallery, Joe's had been shown widely in the Northwest. The locations of Tom's paintings were meticulously catalogued only in his head; Joe's were filed in several different gallery offices.

Fortunately, the Greg Kucera Gallery had recently begun to represent Joe. During the course of our work, Greg and his outstanding staff were cataloging Joe's work from its beginnings to the present. They thus became natural partners on the project: their judgment and advice are evident everywhere in the book. And, of course, each artist reacted differently to being the center of so much attention. Tom, innately modest, had to be constantly convinced that he deserved to be the subject of a book. Joe was more sanguine but less accessible as he worked in a remote part of eastern Washington found only by following fence posts.

By 2007, we realized we were onto something bigger than the two books. What had started in that living room created a momentum beyond anyone's expectations. The original logic—to give Tom's paintings a wider viewing—somehow tapped into a sense that there were more stories to tell about more artists, who, however different in age, gender, training, or medium, shared a singular bond: they have spent their lives devoted to their art, unwilling to compromise their talents for assurance of rewards or certainty of salaries, working largely by themselves, often with little fame or fortune to show for their efforts.

That sense, which has become clearer in hindsight, was forged into a mission: *to support publications on artists working in the Northwest whose work deserves a wider audience.* And with that statement, the Thomas T. Wilson Series, and an accompanying book fund housed at the University of Washington Press, was established.

The next chapter of this history took an unexpected turn. While the Goldberg project was still in the making in Seattle,

a group of friends and admirers of Harold Balazs had begun a similar effort to document and celebrate his life and work, which is centered in Mead, a small town north of Spokane.

The resulting book, published in 2010, is a masterful effort to describe Harold's generous and vibrant nature and to document his many-faceted talents, from jewelry making to painting to sculpting.

It was through a happy convergence of circumstances that the book joined the Wilson series at the University of Washington Press. Although all the necessary effort for such an undertaking was accomplished in the Spokane and Coeur d'Alene area, it became clear that a major Northwest press was needed to publish an artist as expansive as Balazs. The resulting publication has proved the wisdom of that decision. The book now takes its logical and proud place with the first two in the series.

Our fourth artist, Anne Hirondelle, moves the series once again into unexplored territory: the world of clay as given shape, surface, and color by a masterful ceramist. Her career-long focus on clay as a medium explodes the assumptions held by many who think of ceramics as a secondary art form, more practical, less "serious," than other materials such as oil, stone, bronze, wax, even watercolor. Exposure to Anne's career and work makes short shrift of this charge.

From her early majestic urns to her recent cups that wink playfully at their humble origins, from her architectural impulse for sedate forms to her bright ropes of clay coiling to the sky, Anne keeps exploring new possibilities without rejecting the traditions of her chosen material. Jo Lauria, a former curator of the Los Angeles County Art Museum and nationally published ceramic critic, captures well Anne's ability to move "from the functional to the nonfunctional" and "between the predictable and the unexpected." Lauria's essay, which appears in the book, observes: "Every new work feels warmly alive and every new series seems animated by fresh ideas." Indeed, one never knows from show to show what surprises Anne may have in store for her viewers.

With the same deliberateness and discipline that pervade her art, Anne chose to live (dwell is perhaps the better word) in Port Townsend, a small seaport on the Olympic Peninsula. This is the same small town where Tom Wilson had his most productive period, in the 1960s and 1970s. Although Tom left before Anne and her husband, Bob Schwiesow, arrived, the two artists admired each other's work, and Tom has championed Anne's in Seattle's art community whenever he can. As settled as her life has remained, her work has traveled to shows throughout the United States and abroad and is lodged in some of our country's finest museums, and the White House Collection at the William J. Clinton Library. Furthermore, through residencies, lectures, and workshops, Anne has personally influenced colleagues and students around the country. "All," she recalls, "have fed my work and given me a sense of community. . . . In short, I've had the good fortune to go where my work has taken me."

Anne has been the recipient of a National Endowment Fellowship for the Visual Arts and a number of awards in Seattle, her latest in 2009 being the Irving and Yvonne Twining Humber Award for Lifetime Artistic Achievement. This peer recognition, the highest form of praise, has not turned Anne's attention away from her work. Every day she crosses from her warm cottage kitchen to her studio and begins anew. With that dedication and accomplishment, Anne stands with the best of her peers. We welcome Anne Hirondelle as she joins Tom Wilson, Joe Goldberg, and Harold Balazs in this series. Different in creative temperament and work habits, these artists nevertheless share what is most important: a lifelong commitment to their work, and their contributions to Northwest art—all of which deserve to be experienced by new audiences, fellow artists, and faithful friends.

This brief history would not tell the whole story about the Thomas T. Wilson series if it stopped here. For behind, before, during, and after each publication resides a host of people who make everything possible. The initial discussions about and with artists, their fit with the mission of the series, finding owners and getting permission to include their art, getting the pieces photographed and returned safely, choosing and rechoosing what pieces to include, deciding who should write about each artist and who should design the book, hosting parties and shows, and, of course, seeking (and giving) funds to support such an enterprise—all of this has been accomplished largely by those whose only pay has been immense satisfaction. Each book has its own history, which has been lovingly told by each and is worth revisiting. To rename all those who came before this one would call for a list of close to a thousand names!

Some of us have been with the series from the beginning, and more have joined with us to bring one or another book to its completion. Together, our efforts can better be described as serendipitous than studied, improvisational rather than professional. That latter quality points to what the University of Washington Press has provided: a ballast to our wind. Without its guidance, experience, patience, and generosity of talent, this series would not exist. Beginning with Pat Soden, the director; Nina McGuinness, advancement officer; and Mary Ribesky, managing editor, the staff at the press have been unfailingly supportive, not only through their professionalism but by their hands-on participation. We still chuckle at Tom's book launch when the books had not yet arrived. Nina retrieved a few copies from a Seattle dock

just in time for Pat's welcoming speech to the donors. Luckily, other events have been less harrowing!

It is this same cooperative spirit that has imbued the making of Anne Hirondelle's book. Its beginning can be traced to Nora Porter, friend and early collector of Anne's pieces. In 2007 Jake Seniuk curated a show of recent Hirondelle work at the Port Angeles Fine Arts Center, a show confirming Nora's idea that Anne would be a fine and fitting artist to join the series. And now, some five years later, that idea has become real.

To make that happen, Francine Seders, who represents Anne in her Seattle gallery, joined the committee, as well as Pat Scott, long associated with the gallery. Francine, Pat, and Anne spent hours bent over a light box and in front of a computer screen, choosing which images best showed the range and quality of Anne's artistry. Working at the same time, the writers, Jo Lauria and Jake Seniuk, added insights and preferences in the text. Their essays, bookending the chosen plates, are elegant analyses that make each piece come alive off the page. The award-winning designer Ashley Saleeba has joined the other University of Washington Press members to produce this visual gem. Shirley Collins, Mary Coney, and Tom Wilson have continued their roles as liaison with the artist, the press, and, of course, the many generous donors who have come forth at a time when money for the arts has been scarce.

It is a tribute to all that this latest addition to the series achieves the same high mark for beautiful books about truly fine artists. As the series continues—and it will—we hope you will join in the pleasure of making more books of great beauty.

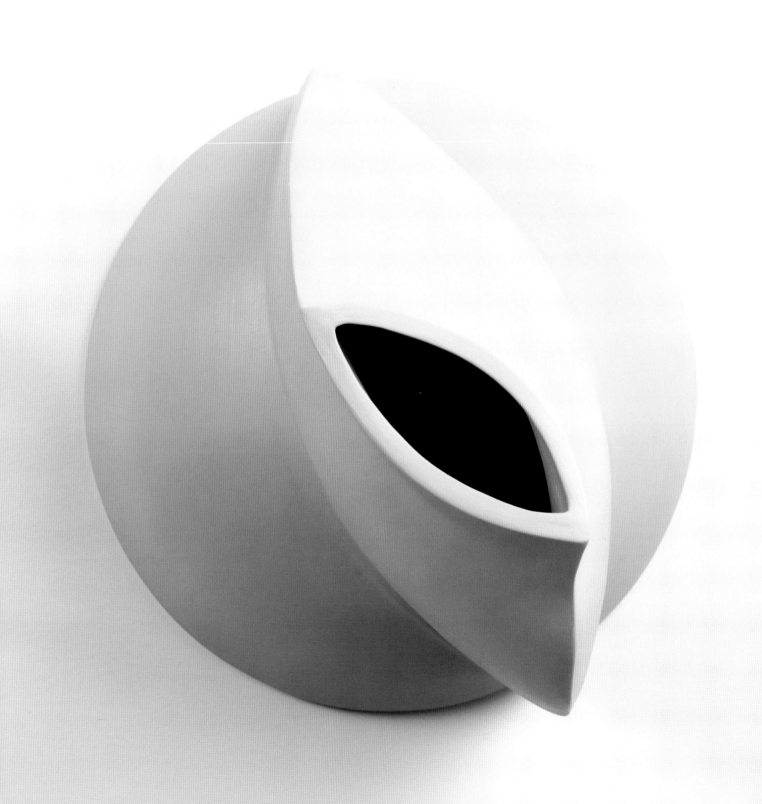

Jo Lauria

Giving Voice
to Imagination

Anne Hirondelle is a keen interpreter of the ceramic experience. Hirondelle has found her aesthetic integrity wedged in clay, ready to be molded and shaped by her expressive hands. Choosing the path of the studio artist, Hirondelle tackled a new visual language, experimented, and then pushed the limits of traditional pottery to explore varied modes of personal expression. In the process, she created forthright and exuberant ceramic vessels and sculptures that demand, and reward, close examination and critical attention.

A Song Worth Repeating

Hirondelle's diverse, inspired approach to the medium of ceramics can be seen in the evolutionary development of the work. An overview of twenty-five years reveals the artist's constant dialogue with material and form, and her ongoing relationship with visual concerns driven by rigorous formal logic: the tactile love of materials and emphasis on surface—always a constant; the frequent trading of symmetry for the asymmetrical to play balance against tension; the sensually organic coexistent with the boldly geometric; and the crisp lines and glow of white, unglazed clay objects bridging to the exuberant, color-infused biomorphic sculptures—each distinctive grouping at opposite ends of the optical scale, yet equal in beauty. This progression can be traced through the artist's successive series of works and reprisals of primary forms.

The astute observer can document Hirondelle's major movements through the decades: away from the functional toward the nonfunctional, from the volumetric vessel toward the vessel deflated and deconstructed, and from the mono-

chromatic toward the prismatic. The dynamism Hirondelle has consistently established in her work between spaces—positive and negative, interior and exterior, and between the predictable and the unexpected—keeps the viewer alert. Every new work appears warmly alive, and every new series feels animated by fresh ideas.

Home Is Where Imagination Lives

If one's creativity and artistic experiences could be drafted on graph paper, Hirondelle's ascending arc would chart a dramatic increase in technical virtuosity, confidence, and compression of knowledge. Hirondelle's creative and imaginative life begins and ends at her home in Port Townsend, as she works in her studio. The studio is the nerve center where Hirondelle engages daily in an intensive exploration of materials, testing her ideas and skills against an imaginary bar of ideal beauty that she is continuously raising. And, as an artist working in clay, this space serves as a fortress from whose security she battles against the art world hierarchies that attempt to identify her by the materials she uses rather than by the inspired use of those materials.

Upon leaving the ceramics lab at the University of Washington, where she had studied with the renowned teacher Robert Sperry from 1974 to 1976, Hirondelle and her husband, Bob Schwiesow, reclaimed a small outbuilding next to their house for a studio. The whole evolutionary line of Hirondelle's artwork can be traced back to this marker—her modest first studio created in 1977, then an expanded version built adjacent to it in 1994. As Hirondelle asserts, her entire discovery process has been "through doing and experimenting" in her studio. It is there that the formal sculptural properties of line, space, volume, and mass have been investigated and learned through her hands as they shape the clay. Additionally, through calculated trial and error, it is there that she has mastered glaze technology and formulated her original glazes.

The artist's first inclination immediately after leaving the safety net of the university ceramics program was to further develop her skills and become a production potter. The years 1977 to 1979 were a concentrated period of production. The artist refers to this time as finding her way "through thrown forms." She rigorously investigated the requirements of form and function by shaping utilitarian stoneware pieces on the potter's wheel. Functional vessels based on cylinders comprised her standard line of serving ware and baskets, a design direction that continued through the early 1980s. In hindsight, Hirondelle's discerning eyes are critical of the work she produced at that juncture. The vessel shapes borrowed heavily from traditional forms, and the decorative treatment remained safe and conventional, much as her selection of Asian-inspired glazes resulted in handsome but familiar surfaces.

By 1981 Hirondelle had exhausted the repertoire of functional forms and was searching for a new challenge, one that would lead her to a more authentic expression in clay. Above the whirl of the potter's wheel, the artist kept hearing the words of her teacher, Bob Sperry, resounding: "If you want to do anything that is distinctly your own you're going to have to break the rules." During this decade, potters who worked with raku were considered risk-takers and rule-breakers. Hirondelle enthusiastically joined their ranks when she built a raku kiln and decided to "let go of the whole notion of function." The artist was heeding the voice in her head. Freed from the tyranny of utility, Hirondelle began to make vessels with extruded additions built at a larger scale (beyond functional size), and she decorated them with one of the four unique raku glazes she had developed. These custom glazes were formulated with different oxide combinations to produce a varied palette, and their deliberately high lithium content provided the result Hirondelle was seeking: a rough, matte, and non-glossy surface. The production potter had suddenly gone rogue.

Looking through the long lens of time, Hirondelle sees this both as a period of fervent experimentation and as a crucible of her commitment. The raku forms evolved from 1981 through 1985 and become increasingly more constructed and architectural. Although most of Hirondelle's pieces were intended for pedestal display and were finished with fired glazes, she also tried new formats, including wall-mounted constructions that were airbrushed with white acrylic. This venturing into paint as the preferred decorative option would resurface in Hirondelle's later works, beginning with the *Go* series (plates 27 and 28).

Turning Points and Signposts

After four years of working with raku, Hirondelle started to question its durability and permanence and decided it was time for a change. As the smoke cleared, the artist considered her development. Raku glazes and the smoking technique of raku firing had yielded a desirable charred and matte surface that captured and held her interest; raku's surface qualities seemed endlessly variable and mysterious. Even so, as equal parts artist, chemist, and scientist, Hirondelle set out to formulate a new stoneware clay body and complementary glazes that would simulate the textures, colors, and mottled effects of raku while providing the strength and intransience of high-fired stoneware. After innumerable glaze tests, Hirondelle devised a single base glaze—extremely high in soda ash—that she could vary by using four different oxide combinations. Each of these four variants produced unique colors—she called them "patinas"—and surface textures, depending on the thickness of their application and the firing atmosphere in the kiln (reduction versus oxidation). Although unpredictable, these glazes offered a rich palette of colorations as well as dynamic surface effects that were original and exciting.

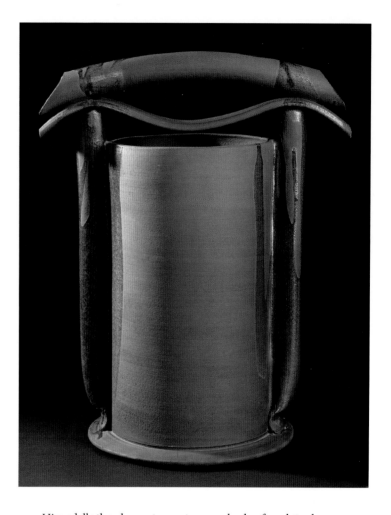

Hirondelle then began to create a new body of work to showcase the recently formulated glazes. This series was based on functional vessels built at more or less functional scale. The artist's past experience in working with raku had a direct influence, as evidenced in the coarse surfaces, exaggerated scale, and more sculptural character of these new stoneware forms. But Hirondelle also began to document this work through working drawings executed on graph paper. These blueprints, as she called them, mapped the creative process from initial sketch to the final drawing of

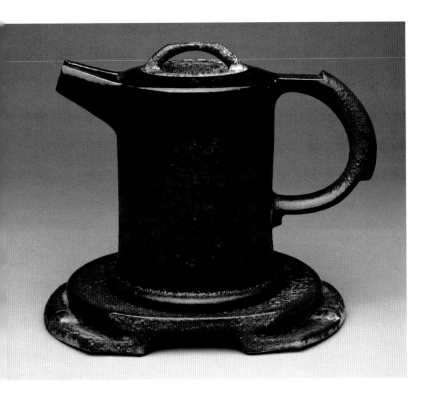

the design as it was actualized in clay. Hirondelle discovered that the working drawings began to inform the work, serving both as points of reference and archival records.

Hirondelle exhibited this new work at the Northwest Craft Center and Gallery in Seattle in 1985. Seeing the vessels in a different context, that is, in a gallery versus in her studio space, provoked a revelation for the artist: for the first time she recognized the sculptural potential of her work in clay. This was a moment of deep lucidity for Hirondelle. Not belonging to any formal community of ceramic artists—Hirondelle preferred isolation—she had learned to trust her instincts and now was excited by the results. Wanting to share her discovery, Hirondelle sent a selection of transparencies of these new pieces to the two key publications in her field, *Ceramics Monthly* and *American Craft*. Her efforts

were rewarded with a feature she was asked to write about her work for *Ceramics Monthly* and a profile piece in *American Craft*.[1]

This was the first national exposure of Hirondelle's work, and she found the response overwhelmingly encouraging. Her pieces were referred to as simple, strong, and architectural. They were praised both for their classical, restrained grace and for their vanguard break with tradition: the surface of the glaze was unlike any other in ceramics, past or present, and the formal presentation of the vessels on ceramic bases introduced a new idea. Hirondelle was lauded as an artist capable of embracing many of ceramics' diverse threads. From this point forward, Hirondelle was no longer viewed as a regional Northwest artist but one of national prominence. In this field her work now became a benchmark for others to emulate, clearly being deemed worthy of publication, exhibition, and acquisition. This also marked the point of origin, the beginning, of a remarkably consistent climb up the aesthetic chart for the artist, characterized by intensifying sophistication, refinement of form, and sculptural complexity.

In the succession of series that followed through 2000, Hirondelle narrowed her focus to vessels that referred to function, endowing them with greater scale, sculptural presence, and amplified visual stature (see, for example, plate 1). These forms become amalgamations of a main "body" with additions and extrusions, mainly handles, bases, and knobs. These handles and bases become important compositional elements, and the ceramic "trays" on which the works stand integrate with the vessels to form one silhouette.

The multiple series generated during the next fifteen years followed a trajectory from cylinder-shaped pitchers with single spouts and handles to double-spouted (plate 2) and double-handled forms (see, for example, plate 13); from single objects such as teapots and bottles to teapot multiples (plate 10) and *Bottle Dwellings*; from bells to ceremonial vessels to cups; and on

Fig 3 Anne Hirondelle in her studio, 1986

Fig 4 *Bottle Dwelling: Five*, 1992
Glazed stoneware
17 × 34 × 18½ in.
Collection of Iris & B. Gerald Cantor Center
for Visual Arts at Stanford University

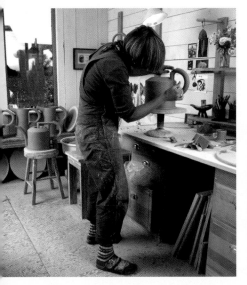
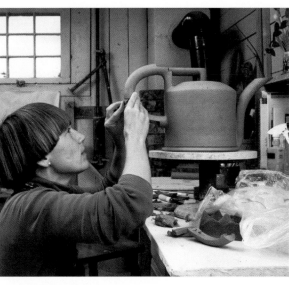
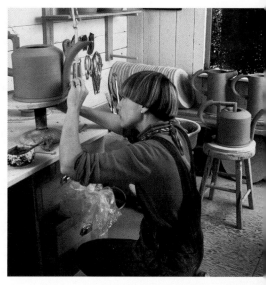

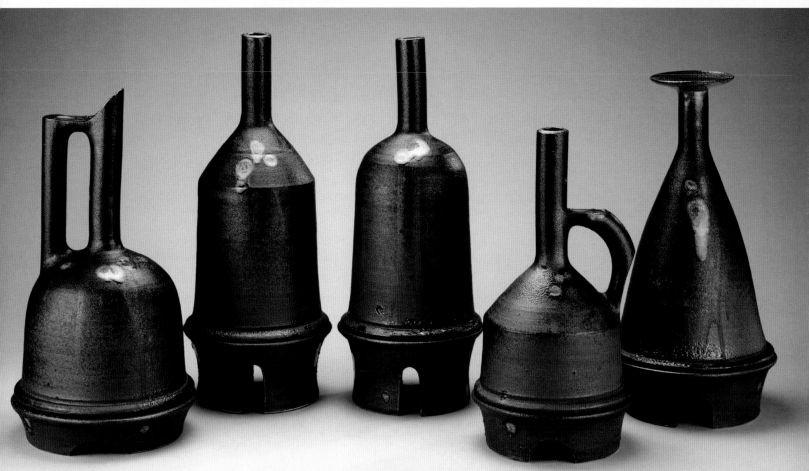

through a series of Greek-named groupings such as the *Aquaria* (large architectonic pitcher forms; see plates 15, 16, and 17), *Kardia* (a pod shape created by two thrown bowls married rim to rim, with an opening at the top; see, for example, plate 20), and *Ocarina* forms (larger versions of *Kardia* pods such as those illustrated in plate 21).

Along the points of this course, certain distinctive themes were introduced, developed, and refined. For example, handles become important structural elements that defined form by their positive-negative space relationship to the body of the vessel (see, for example, plate 8). Also, the "space between" the vessels began to emerge as a potent sculptural concept (see, for example, plates 3, 6, 10, and 14). These themes were most evident in the *Diptychs*, *Triptychs*, *Multiples*, and *Dwellings*: the arrangement of the composition became the primary focus, chosen to exploit the negative spaces between the multiple pieces of a grouping. These in-between, empty spaces were deployed as strategy to move the eye around and through the compositional elements. Further, the crafted ceramic bases now became lacquered wooden trays; it was no longer Hirondelle's intention to simply elevate these pieces but rather to *frame* them as an edged composition. Aesthetically, this compositional direction echoed the still-life paintings of the Italian artist Giorgio Morandi—both in its formal presentation and in its stillness and serenity.

Rhythm into Line, Words into Vessels: From *Turnpools* to *Outurns*

Ultimately, Hirondelle took her permutations of vessel-bound forms and the concept of arranged compositions to their logical end. Casting about for a new direction, in 2001 the artist developed a series of *Echos* and *Turnpools* that she exhibited at the Foster/White Gallery in Seattle. The *Turnpools* were comprised of

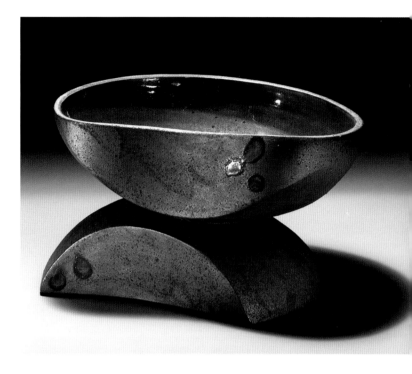

two conjoined bowls, the bottom bowl inverted to serve as the base to hold the bowl stacked on top. The *Echos* were wall-mounted forms. The similarity of the series was in their surface treatment: the *Echos* and *Turnpools* were both decorated on the interior with shiny black glaze and on the exterior with golden pewter.

After the 2001 show, Hirondelle brought these pieces back to her studio and pondered. She felt that the "leap into the unknown" she had hoped for with this transitional work had not materialized. Although she had subverted the perfect roundness of the bowl shapes through the subtraction and addition of clay—variously cutting away and coil-building extensions onto the bowls—she felt the forms were somehow unresolved. Further, she determined they were too comfortable in their skin; they wore the same glazes that had been used on earlier bodies of work, but now these glazes seemed ineffectual.

Seeking clarity, Hirondelle entered a period of frenzied production and made multiple pieces based on the *Echo* form. An inverted bowl attached to a thrown disk was the base from which a coil-built body grew. To resolve the glaze treatment, she hung several of these "naked clay" forms on her white studio wall and contemplated them. As Hirondelle looked at this grouping of unglazed pieces, she experienced an epiphany: the all-over whiteness of the exposed clay revealed shadows and curves and emphasized the sculptural shape, bringing into focus the dimensional form uninterrupted by any surface application. Viscerally feeling the conveyance of energy from these rounded forms derived from the organic shapes of nature, she decided they were more exciting

hanging on the studio wall in this raw, undecorated state. This realization sparked a new direction that led to a series of unglazed wall sculptures that the artist titled *Outurns* (see plates 24 and 26).

Walking the Wire—Crossing into Unknown Territory

Beginning with the *Outurns*, Hirondelle invented new forms as well as a new vocabulary to describe her sculptural objects that had jumped from the pedestal to the wall. This series demarcated a departure from the formal language of pottery and entered the discourse of contemporary sculpture. These forms, and the consecutive series that followed, demanded to be understood on their

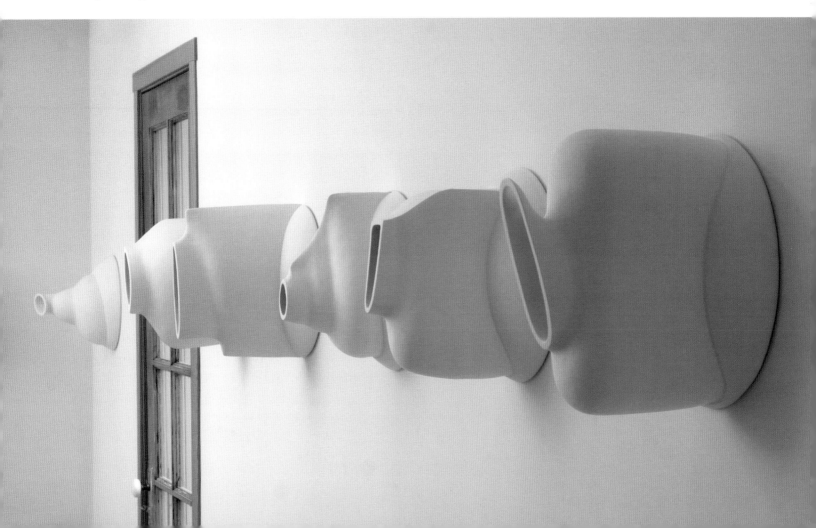

Fig 7 *Go 1*, 2005

Painted stoneware

10½ × 6½ × 9 in.

Collection of Francine Seders

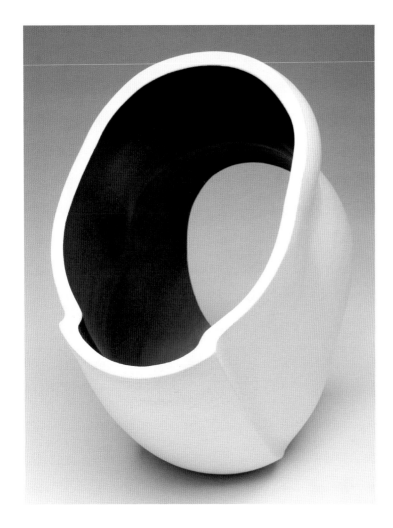

own terms, regardless of material and technique. For the artist, it was a time of letting go of what she knew and what she had mastered, and even an attempt at changing perceptions of who she was. No longer wishing to be defined by her materials but by her inventiveness, Hirondelle began to create imagined forms through an intuitive way of working. She acknowledged that she would not know what the forms would ultimately look like but believed that she would enjoy the experience and excitement of the process.

From 2002 to 2004, Hirondelle created *Outurns* of exposed clay, sanded and waxed, and mounted on the wall. The first formal presentation of this work was in 2004 at the artist's one-person show held at the Francine Seders Gallery in Seattle. The show also included drawings of the *Outurns* (plate 25). Announcement of the arrival of this work outside the Northwest occurred the same year, when an *Outurn* was included in the *Scripps 2004 Ceramic Annual* at Scripps College, in Claremont, California; and also when this work was shown at the Snyderman-Works Galleries in Philadelphia. These introductions signaled to a national viewership that Hirondelle's work had taken a definite turn in a new direction, a direction more aligned with trends in contemporary art that forecast a fresh sampling of different craft materials, techniques, and display strategies for artists working with three-dimensional objects.

For the last seven years, Hirondelle has continued to exploit the basic bowl form (and to a lesser extent a barrel shape) through cutting, altering, sanding, painting, accreting, nesting, reconfiguring, deconstructing, reconstructing, and grouping in grids. Having begun her career as a vessel maker of functional containers, she now denied interior space in her vessels but demanded—as do sculptors—visual space around them. Further, the tradition of applying glazes to ceramic forms was overturned with the *Abouturns*, the first complete series of sculptures to be surfaced with paint (plates 29 and 30). Hirondelle's recent wall and pedestal pieces have experienced the full spectrum of color, going from works with no added color to colored surfaces (from the white, undecorated *Outurns* to the high-keyed, custom-mixed paints in primary colors applied to the *Abouturns*), along with a full array of tonal effects, ranging from intense, saturated directly applied color to the soft, diffused glow of reflected color. (The *Go* forms, *Go Pillows*, and *Tumbles* all played with the effects of color as it reflected on the wall and pedestal.)

Fig 8 *Re: Coil 5*, 2010
Painted stoneware
16¼ × 16 × 12½ in.
Courtesy of the artist and Francine Seders Gallery

In 2007, Hirondelle showed the *Tumbles* (plate 31), *Go Pillows*, *Abouturns*, and *Ready-Set-Gos*, along with more abstract graphite and Prismacolor drawings of these forms on layered tracing paper, at the Port Angeles Fine Arts Center. This daring new work received critically favorable reviews in national magazines.[2]

The positive response motivated Hirondelle to explore and exploit further her practice of delimiting sculptural space by using simplified forms, whether ganged together or united in geometric grids, resulting in the *Remembers* (plates 35, 36, and 37), *Reaches* (plate 39), and *Re:Forms* series (plates 40, 41, 42, and 43).

Continuing a Life's Work: The Song Repeats

Currently Hirondelle has cycled forward to another fertile period of trial and reflection. A flurry of graphite and Prismacolor drawings on layered tracing paper based on the *Re: Coils* (plate 47) has opened up new possibilities for continuing work in this most recent series. The *Re: Coils* (plates 46 and 48) are the first collective group of sculptures in the last ten years that are *not* based on the thrown vessel: here the potter's wheel has been displaced by the extruder. As the extruder pumps out clay coils, Hirondelle takes them in hand and curves, loops, knots, and allows them to meander into freestanding and wall-mounted objects that resemble line drawings in three dimensions.

Hirondelle's endless interest in the interactions among line, surface, and space prompt her to repeatedly rethink the sculptural potential of clay. What new series or recast groupings might next appear on the walls, tables, or floor of Anne Hirondelle's studio can only be left to the freedom of the artist's imagination. Considering the consistent inventiveness and vigor of her past work, one can expect her new sculptures to be graced with structural finesse, clarity of vision, and perfect pitch.

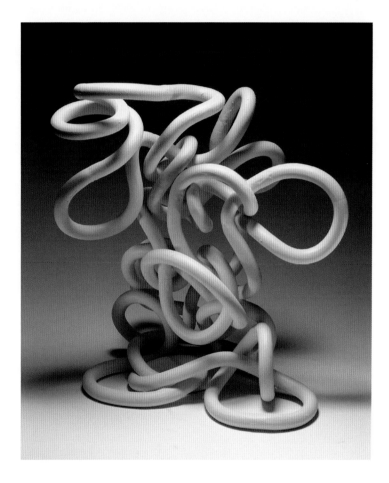

1 Anne Hirondelle [author], "Deliberations," *Ceramics Monthly* 34, no. 6 (June–August 1986): 34–39; "Portfolio," *American Craft* 46, no. 1 (February–March 1986): 45.

2 Important reviews and articles included Matthew Kangas, "De-Constructing Anne Hirondelle," *Ceramics Monthly* (May 2009): 70–73; Beverly Sanders, "Zoom, Preview, Small Revolutions," *American Craft* 68, no. 5 (October–November 2008): 42; Christine Hemp, "Anne Hirondelle," *American Craft* 60, no. 6 (December 2000–January 2001): 60–63; Jake Seniuk, "Outurn, Abouturn and Go," *On Center* 19, no. 4 (Port Angeles Fine Arts Center, July–September 2007): 1–2.

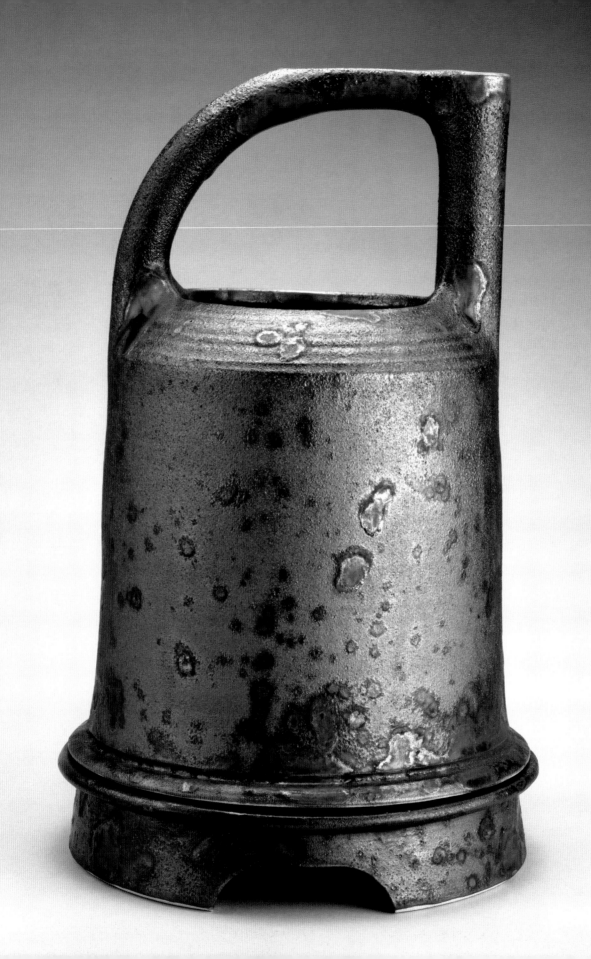

Plates

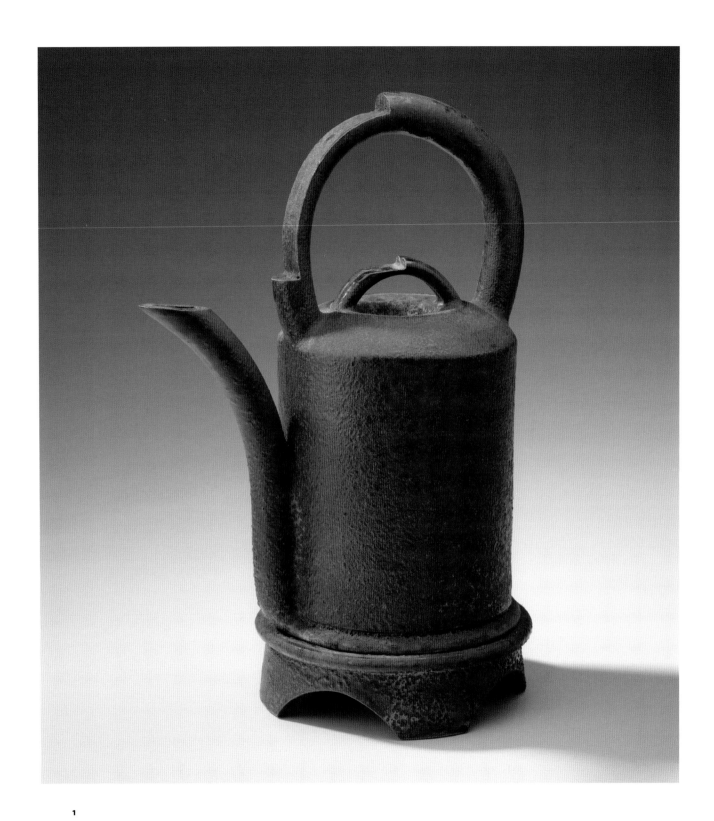

1

Teapot with Base, 1985

Glazed stoneware

16⅛ × 11⅜ × 7¾ in.

Collection of Forrest L. Merrill

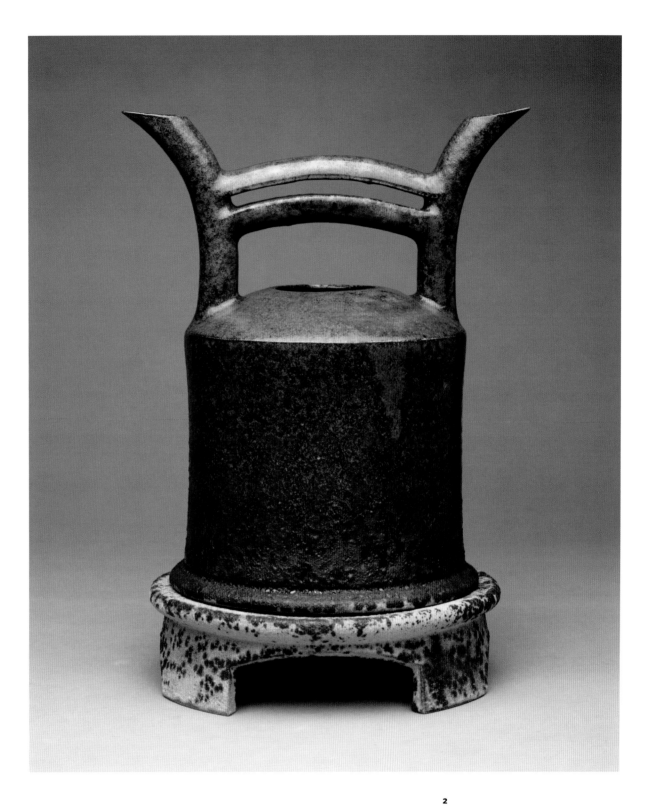

2

Double-Spouted Vessel with Base, 1985

Glazed stoneware

12 × 10 × 9 in.

Private collection

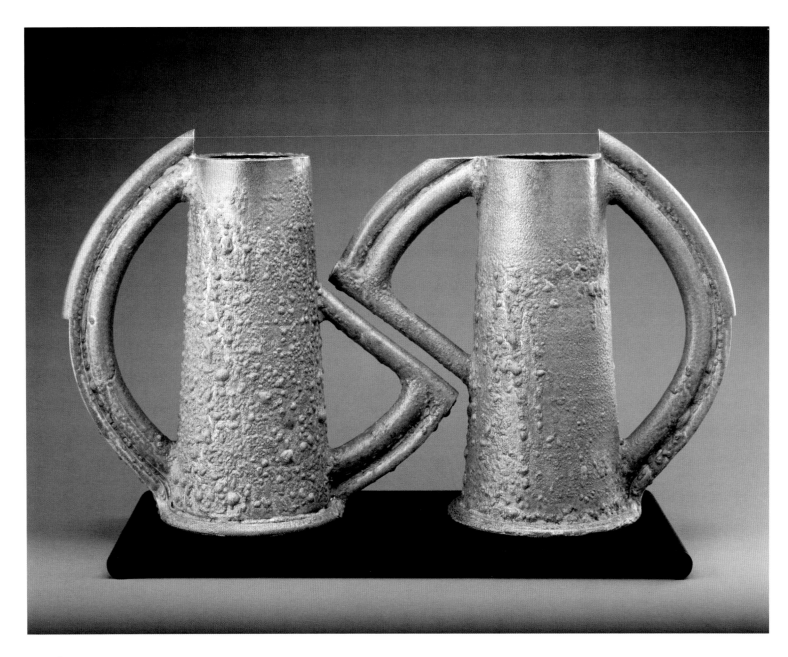

3

Mime Diptych, 1988

Glazed stoneware with lacquered base

15 × 26 × 9 in.

Private collection

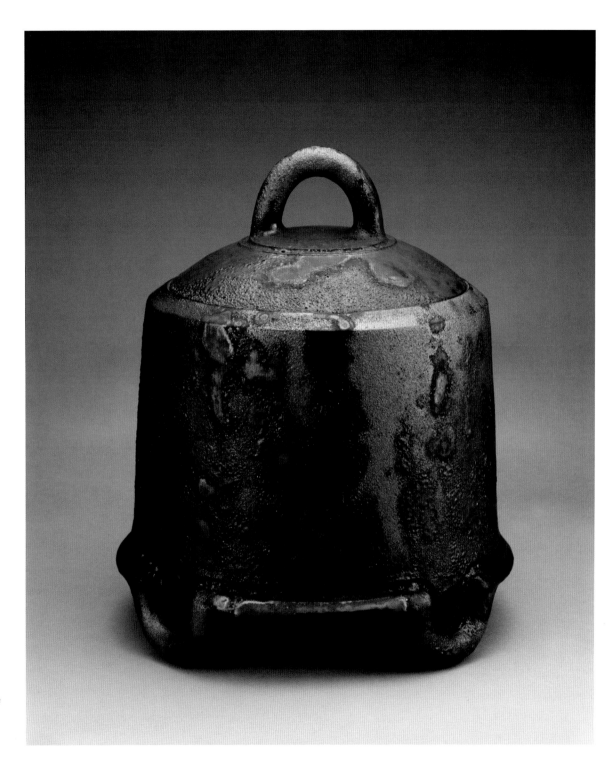

4

Campaña, 1989

Glazed stoneware

12 × 10 × 10 in.

Private collection

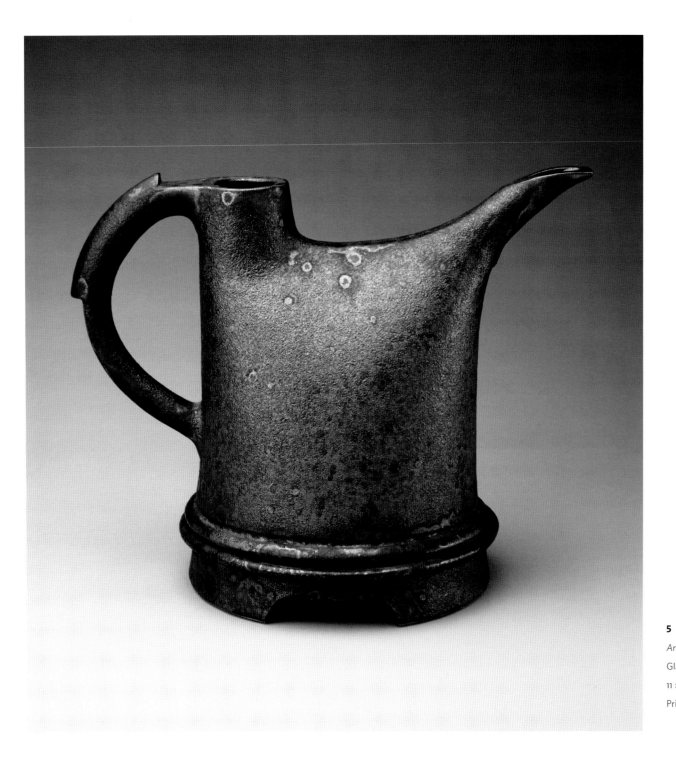

5

Arion, 1989

Glazed stoneware

11 × 14 × 9 in.

Private collection

Dance Diptych, 1990
Glazed stoneware with lacquered base
19 × 26 × 9 in.
Private collection

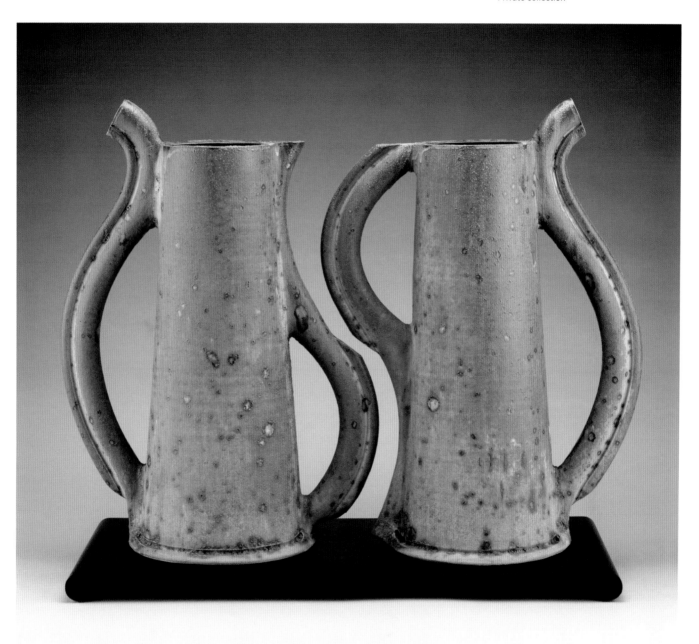

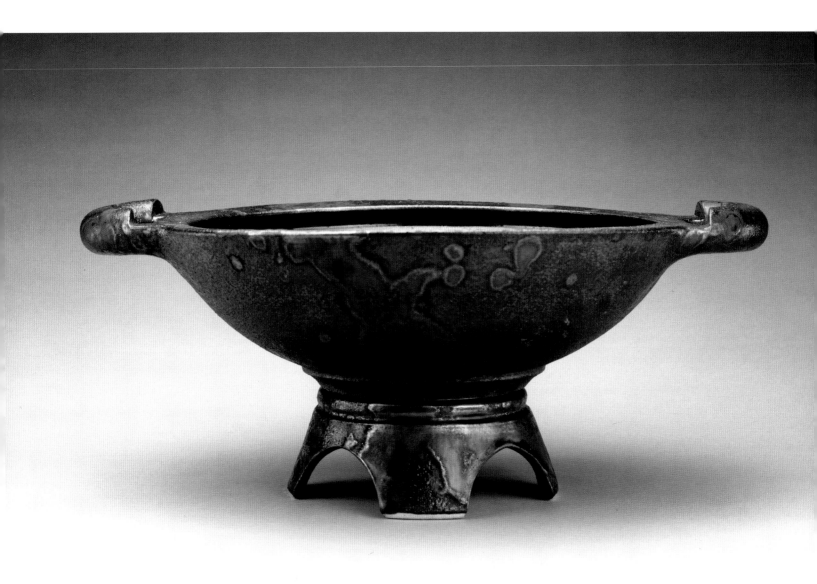

7

Ceremonial Bowl, 1991

Glazed stoneware

7 × 16¾ × 12¾ in.

Collection of Yvonne and Walter Banks

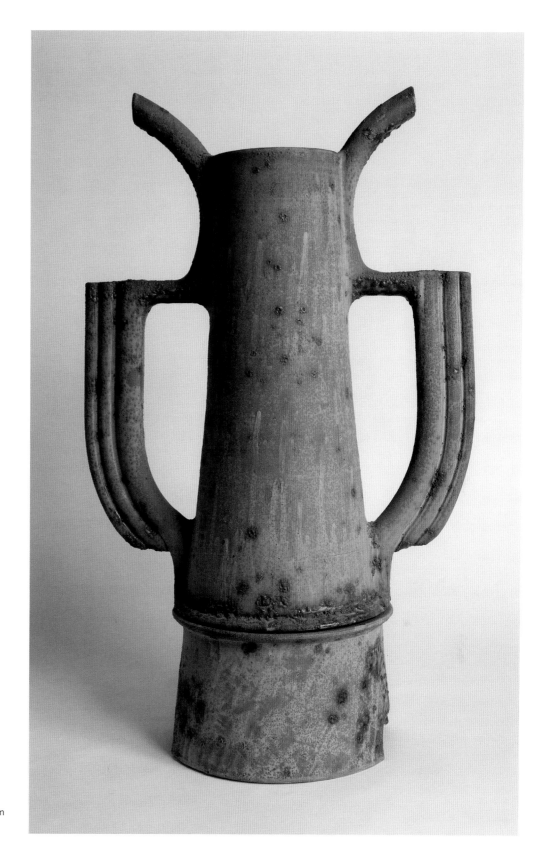

8

Tribus, 1991
Glazed stoneware
26 × 16½ × 9½ in.
Collection of Sharon
and Paul Dauer

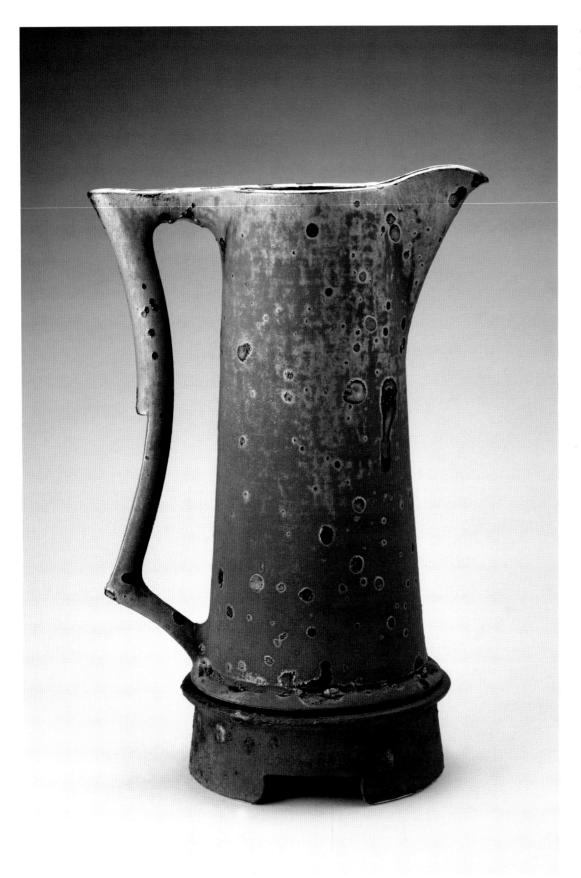

9

Kojin Pitcher, 1991

Glazed stoneware

17 × 11½ × 7¾ in.

Private collection

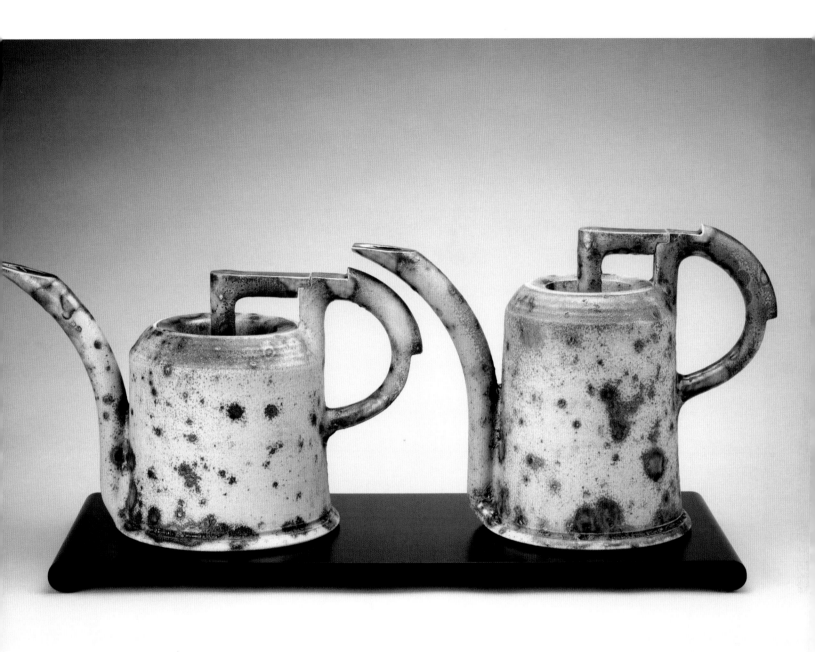

10

Cadent Teapot Diptych, 1991

Glazed stoneware with lacquered base

11½ × 27 × 9 in.

Private collection

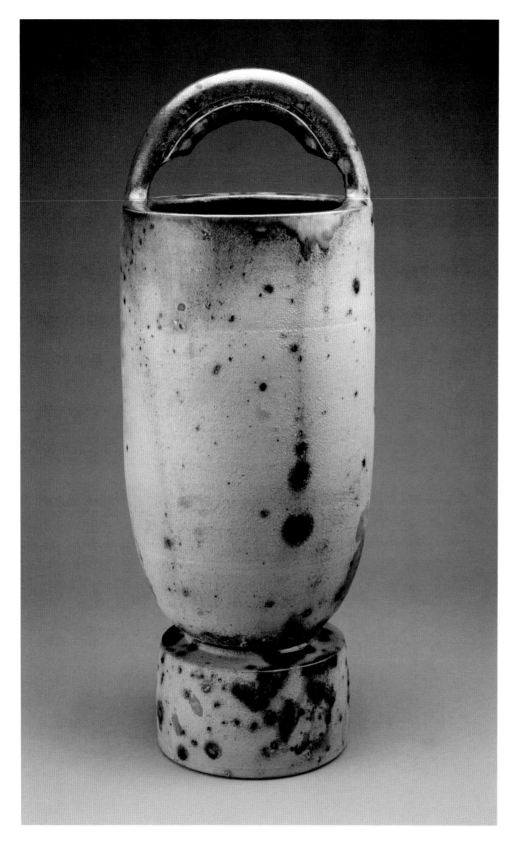

11

Telor, 1992
Glazed stoneware
23 × 8½ × 8½ in.
Collection of Yvonne
and Walter Banks

Karpos, 1992
Glazed stoneware
13¼ × 14¼ × 9½ in.
Private collection

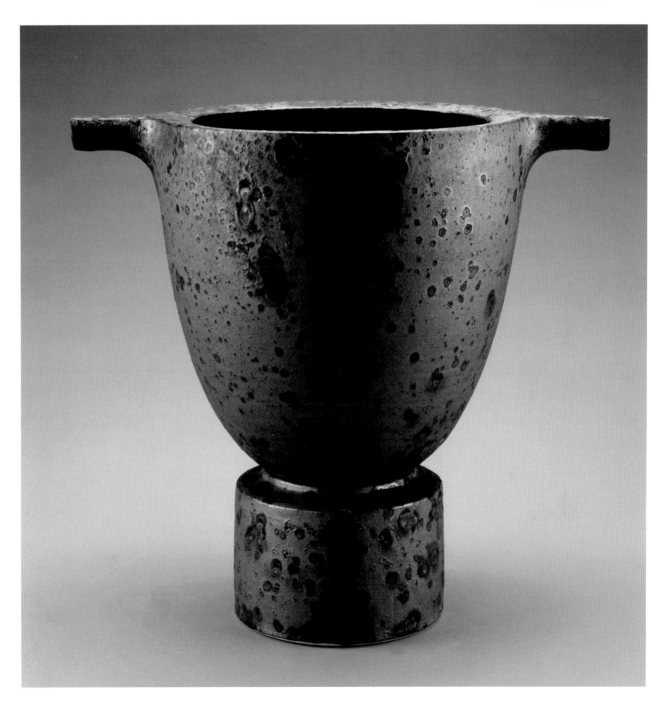

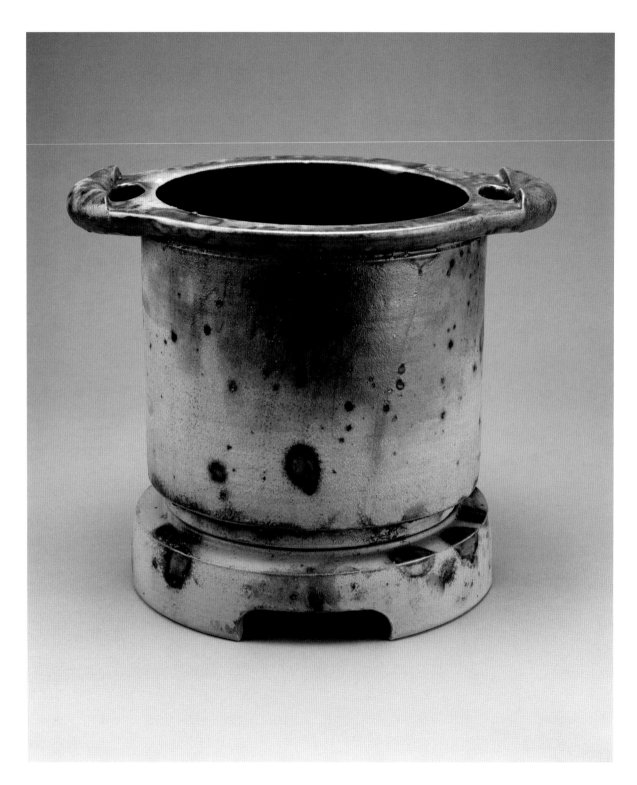

13

Cachepot, 1992

Glazed stoneware

11 × 13 × 10¼ in.

Private collection

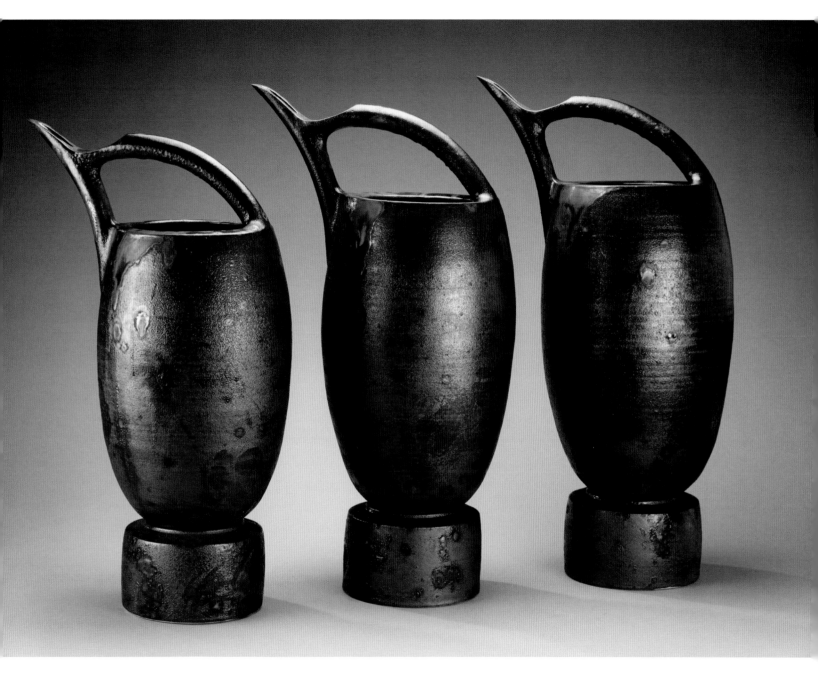

14

Chorister Triptych, 1992

Glazed stoneware

25 × 40 × 10 in.

Collection of Whatcom Museum.

Gift of Safeco Insurance, a member of the Liberty

Insurance Group, and the Washington Art Consortium

15

Aquaria #12, 1996
Glazed stoneware
13 × 17 × 12½ in.
Private collection

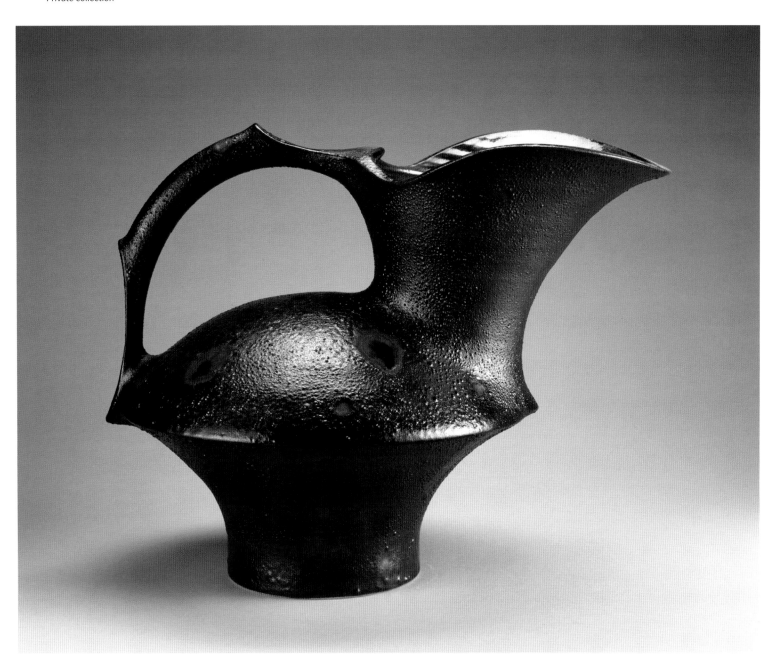

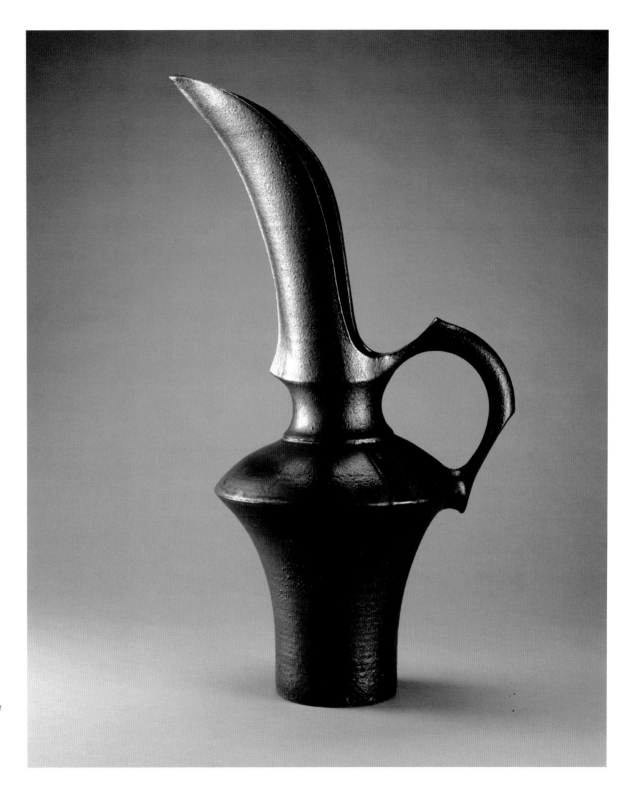

16

Aquaria #27, 1996

Glazed stoneware

18½ × 18½ × 11 in.

Private collection

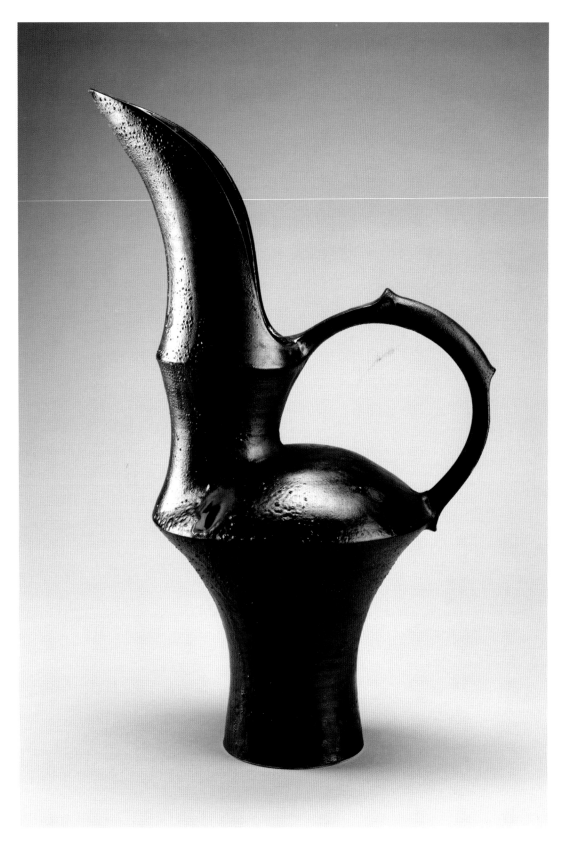

17

Aquaria #55, 1998

Glazed stoneware

23¾ × 14 × 11 in.

Collection of Seattle Public

Utilities 1% for Art Portable

Works Collection

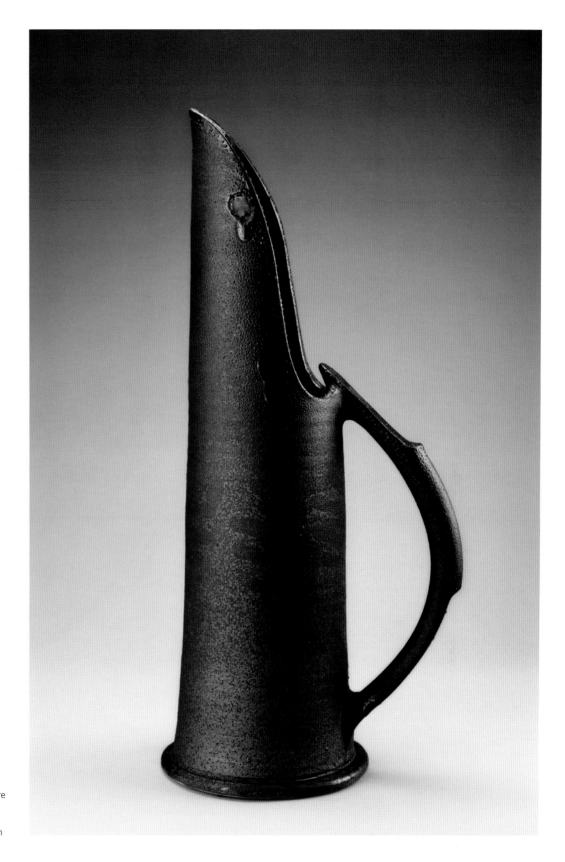

18

Capo, 1999

Glazed stoneware

21½ × 10 × 7 in.

Private collection

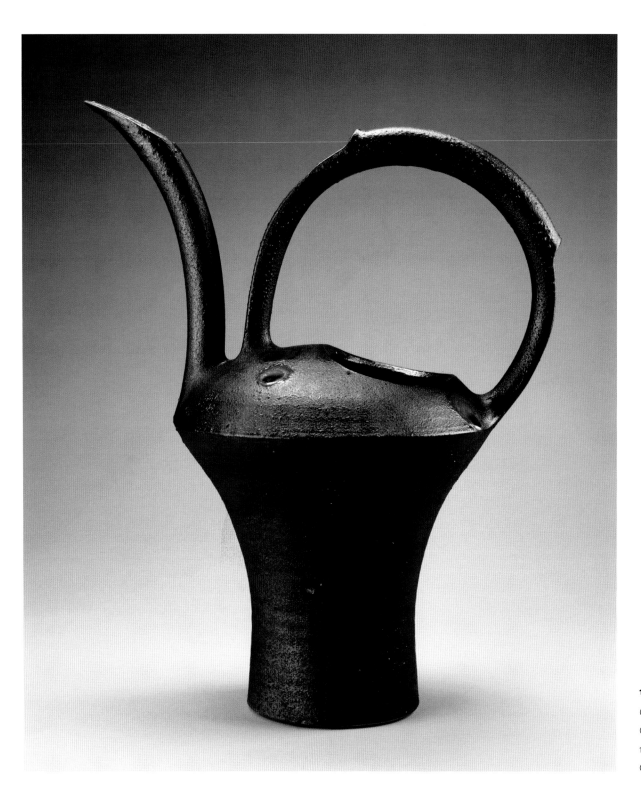

19

Cavatina, 1999

Glazed stoneware

16½ × 14½ × 10 in.

Collection of Martha Mertz

20

Kardia, 2000

Glazed stoneware

9 × 10 × 8 in.

Collection of Museum of Northwest Art.

Gift of the artist

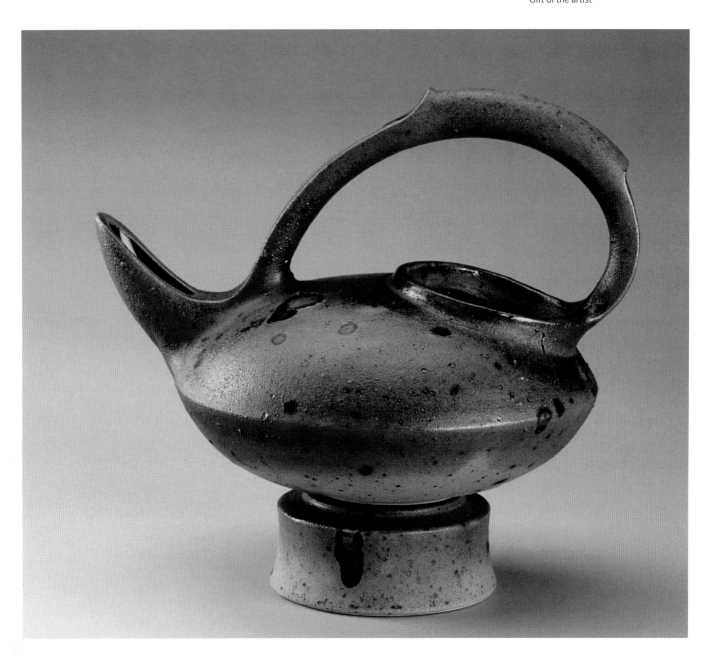

21

Ocarina, 2000

Glazed stoneware

9 × 12½ × 11 in.

Collection of Dennis and Tedi Reynolds

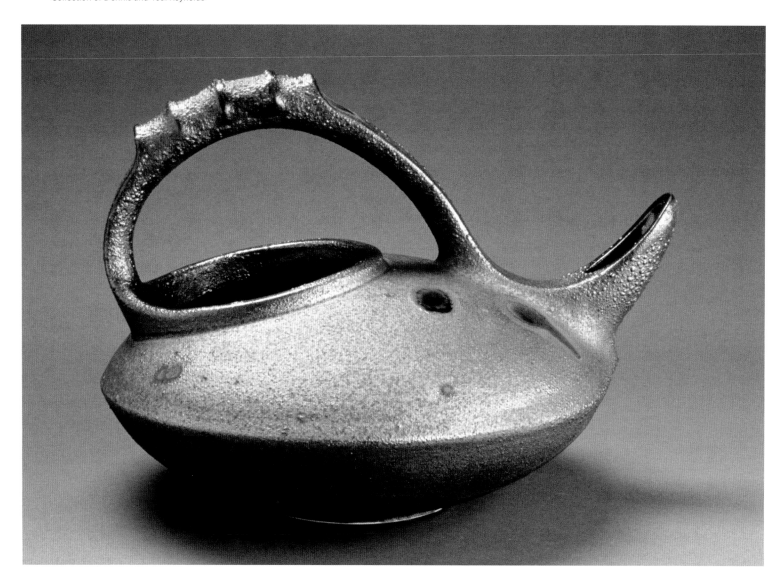

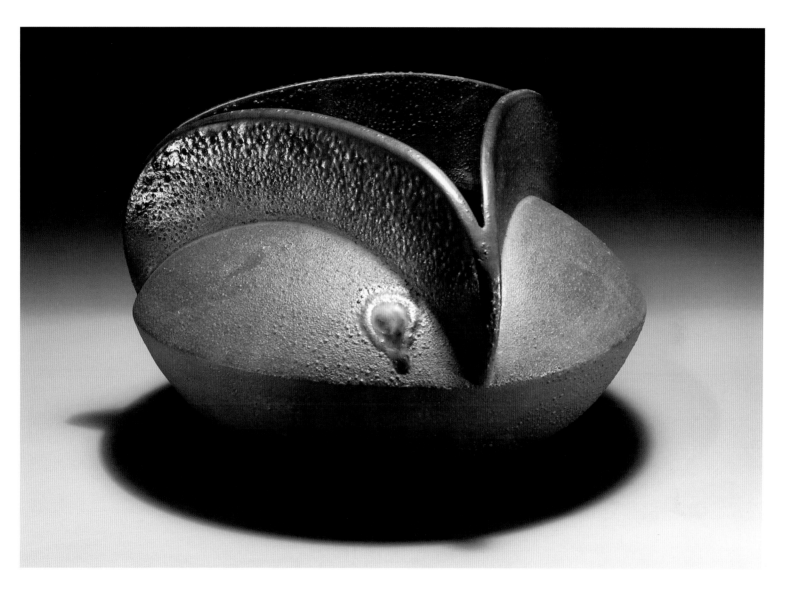

22

Loon, 2001
Glazed stoneware
8 × 12 × 12 in.
Courtesy of the artist
and Francine Seders Gallery

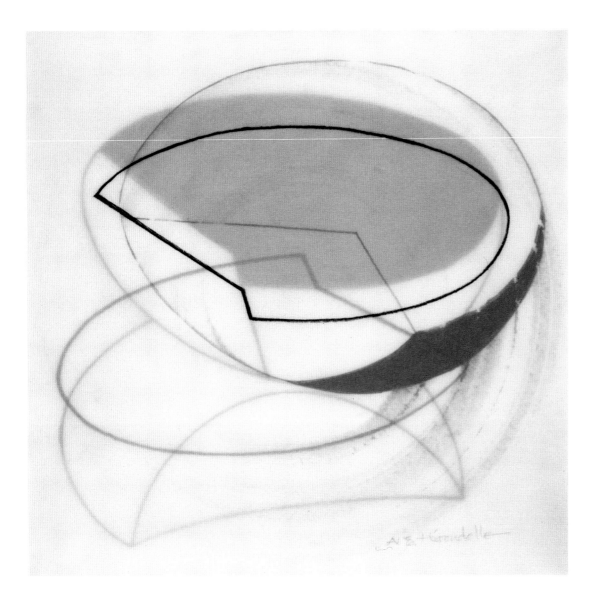

23

Turnpool II, 2002

Graphite on layered tracing paper

10¼ × 10¼ in. image size

Collection of Alison Stamey

Outurn 26, 2003
Unglazed stoneware
12½ × 12½ × 11 in.
Collection of
Sandy Marie Harvey

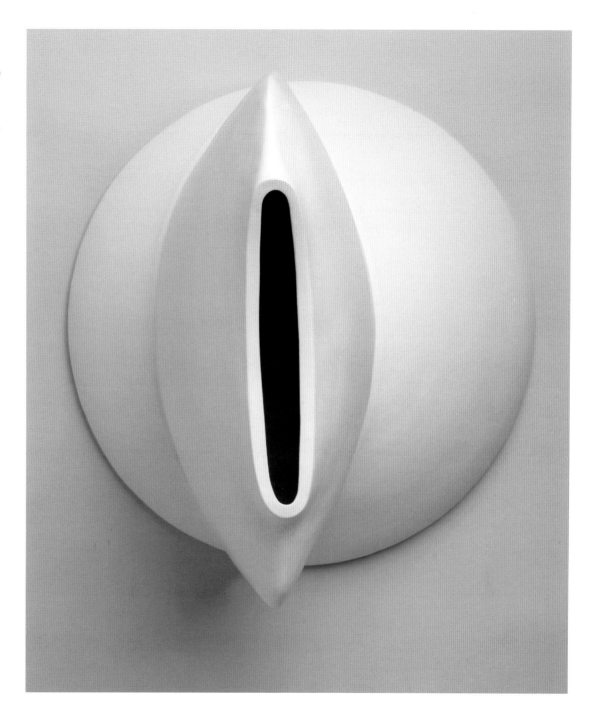

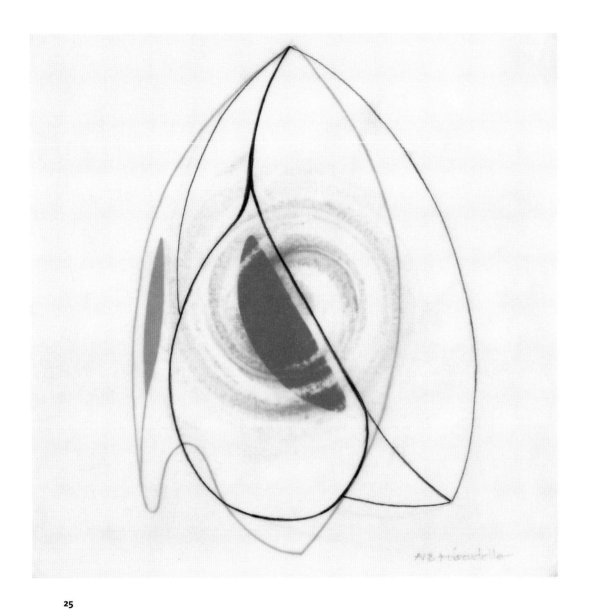

25

Outurn 23 I, 2004

Graphite on layered tracing paper

10¼ × 10¼ in. image size

Collection of Forrest L. Merrill

26

Outurn 23, 2003
Unglazed stoneware
12 × 12 × 9 in.
Collection of Forrest L. Merrill

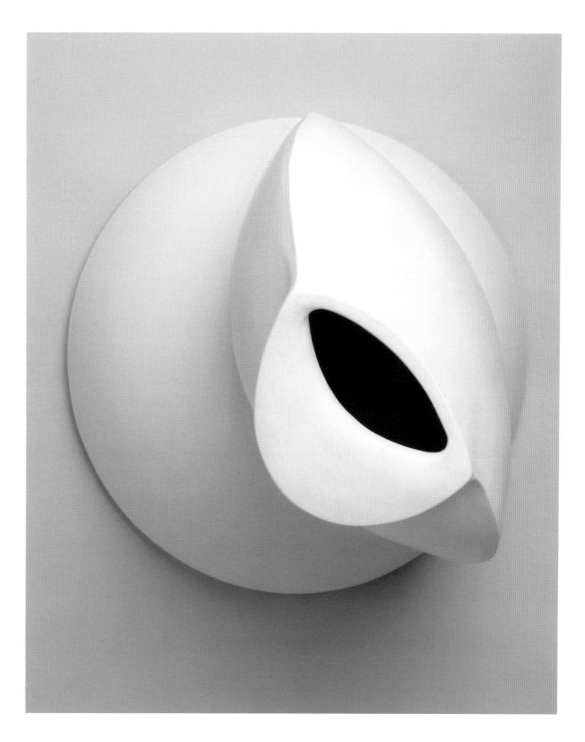

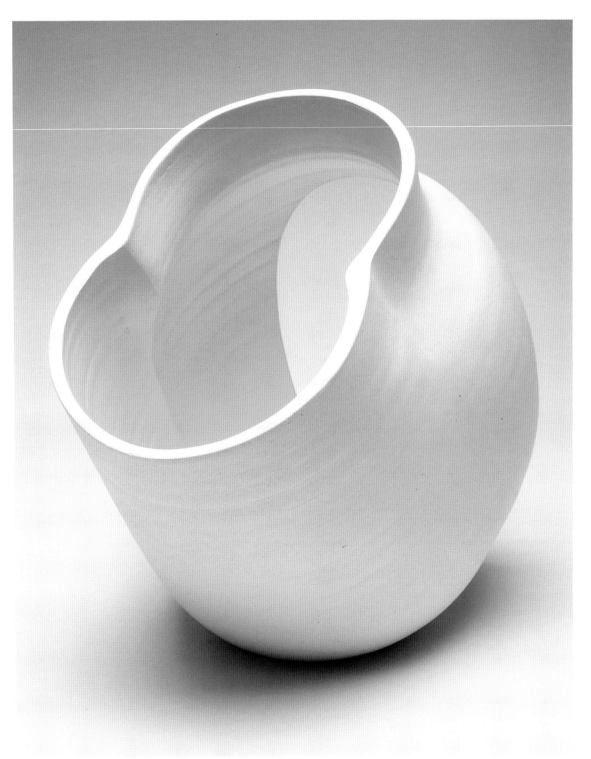

27

Go 7, 2005

Painted stoneware

10 × 8 × 9½ in.

Collection of Paul I. Gingrich, Jr.

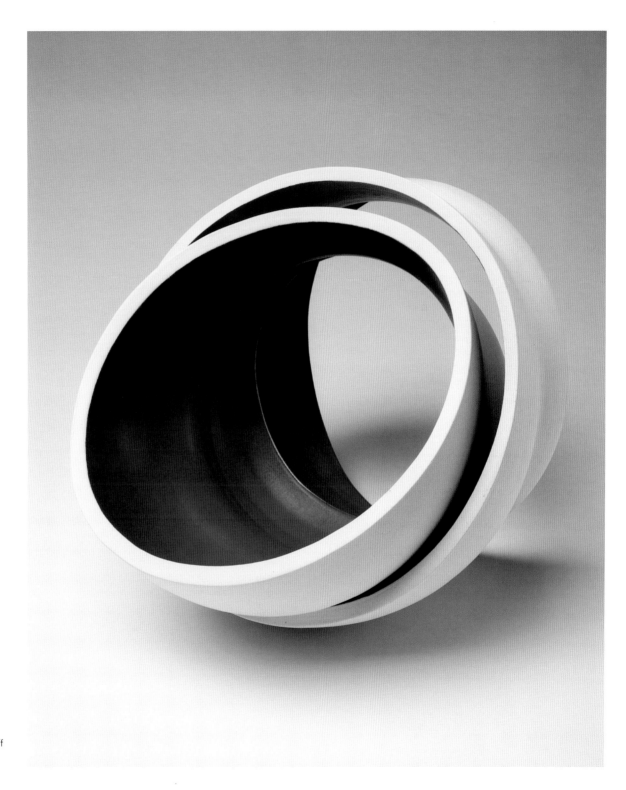

28

Go 10, 2005
Painted stoneware
9½ × 11 × 10 in.
Collection of Steven Korff
and Marcia Van Wagner

29

Abouturn 37, 2007
Painted stoneware
12½ × 12¼ × 8¼ in.
Courtesy of the artist
and Francine Seders Gallery

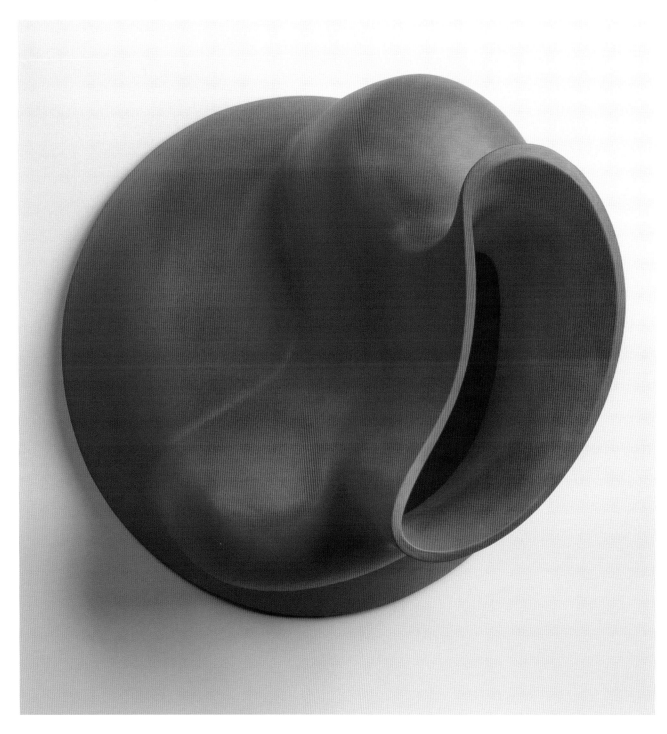

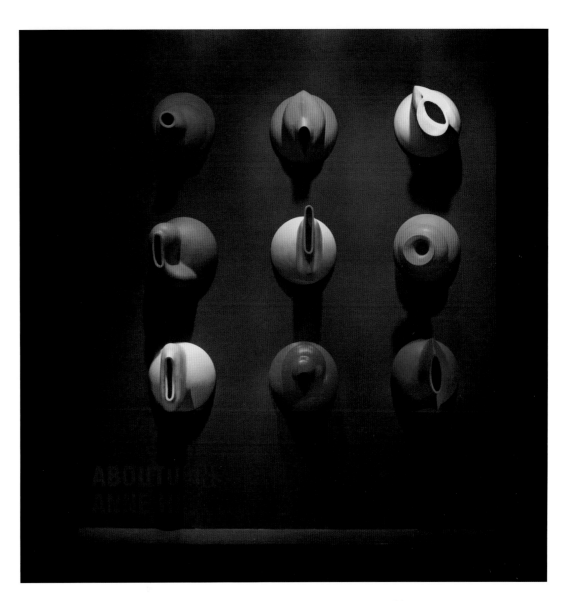

30

Abouturns installation
at Badd Habit, Port Townsend,
Washington, 2009
Collection of Lucy and
Charlie Hanson

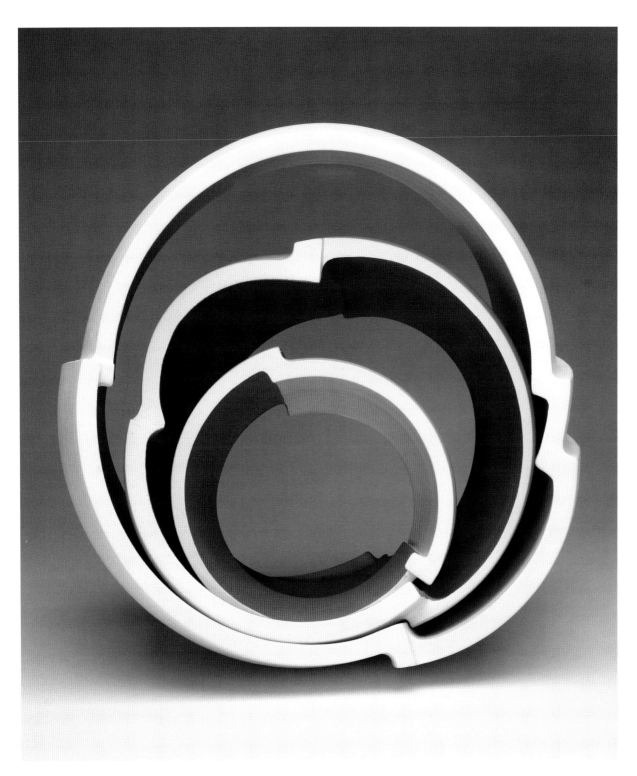

31

Tumble 6, 2007
Painted stoneware
10 × 9¼ × 8 in.
Collection of Diane
and Sandy Besser

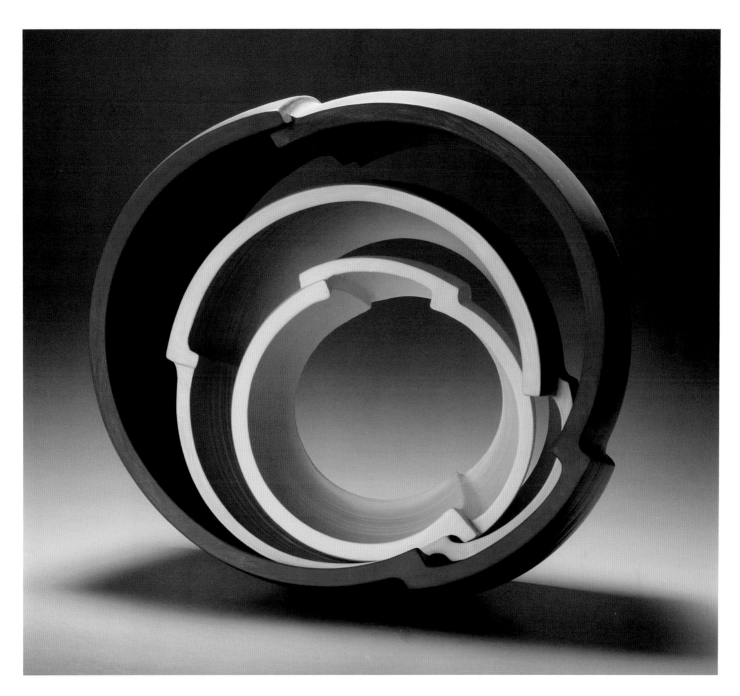

32

Tumble 13, 2010

Painted stoneware

9½ × 10¼ × 7½ in.

Collection of Pat Scott

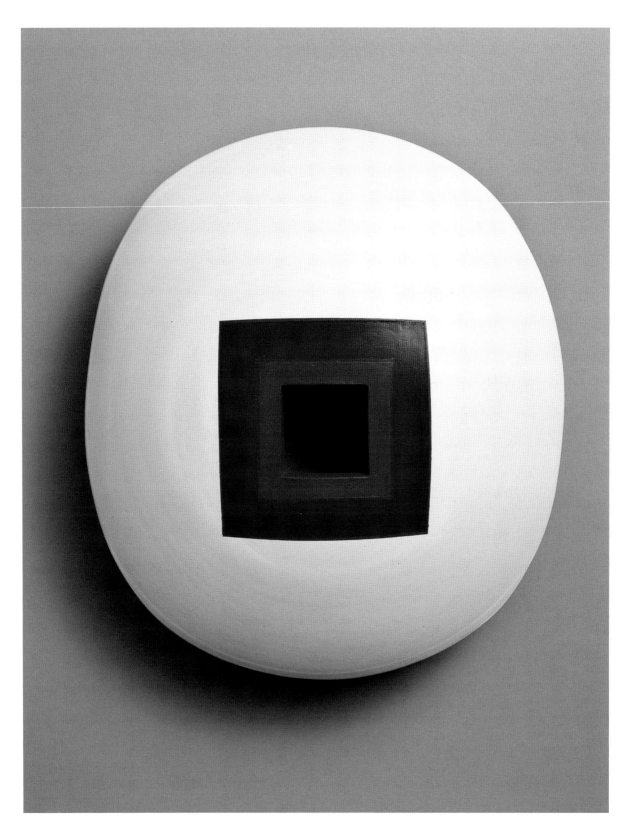

33

Blind 4, 2008

Painted stoneware

11 × 10 × 4 in.

Collection of Renato SM Oliva

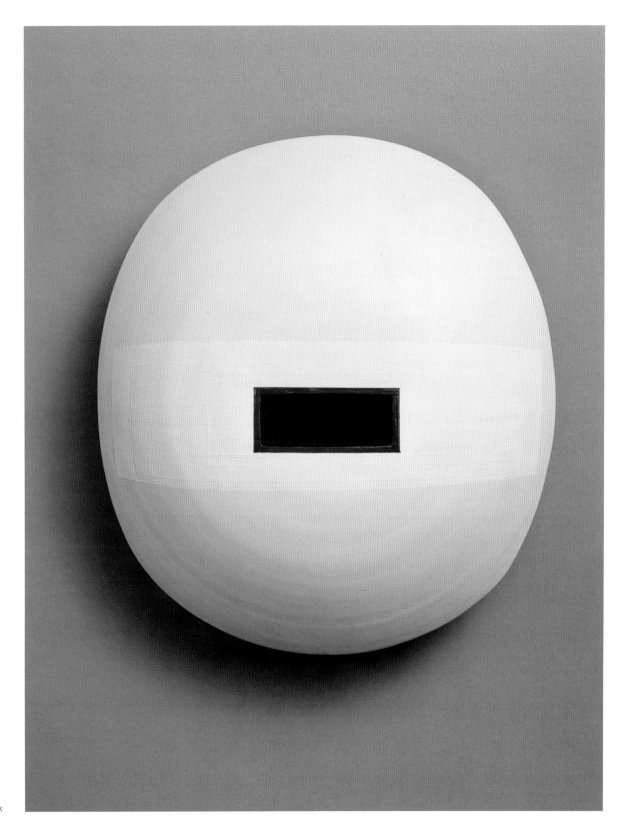

34

Blind 6, 2008

Painted stoneware

11 × 10 × 4 in.

Collection of Barbara Slavik

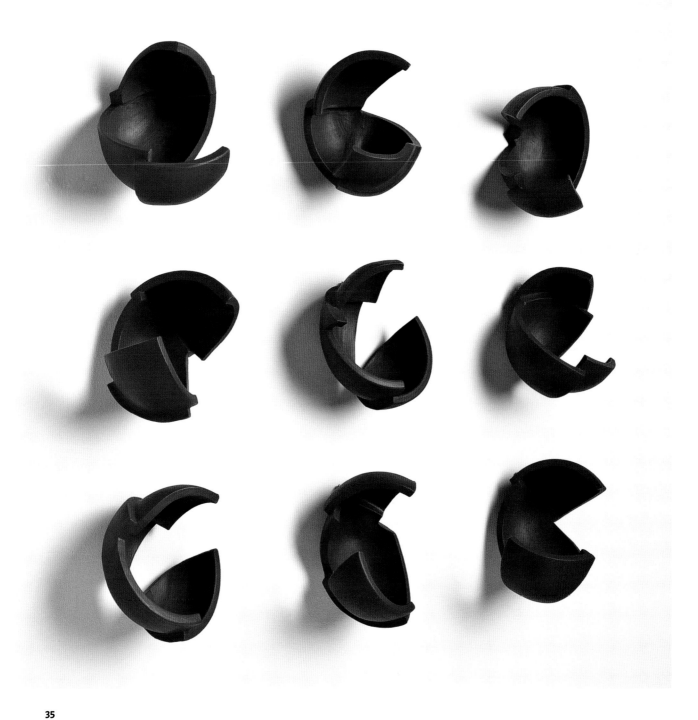

35

Remember Grid, 2008

Painted stoneware

20 × 20 × 5 in.

Collection of Andrea Umbach

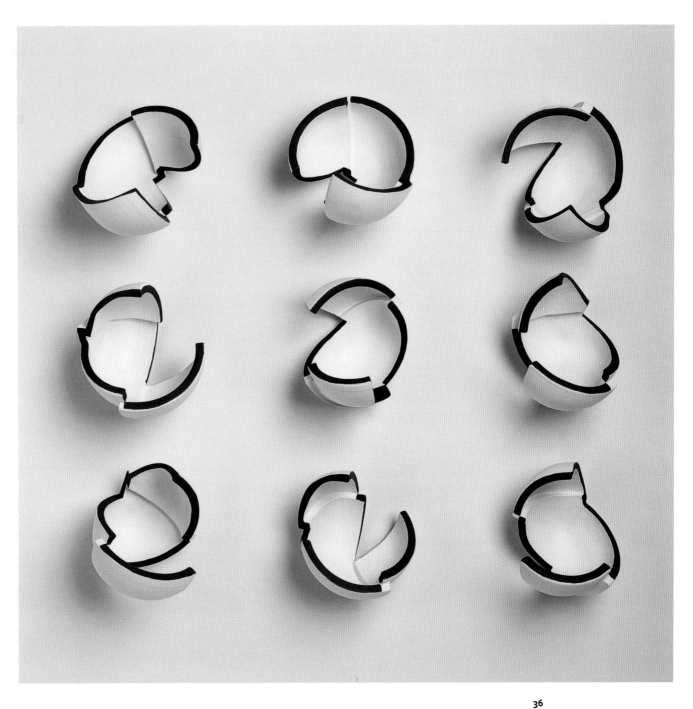

36

Remember Grid, 2008

Painted stoneware

20 × 20 × 5 in.

Collection of Tree Swenson

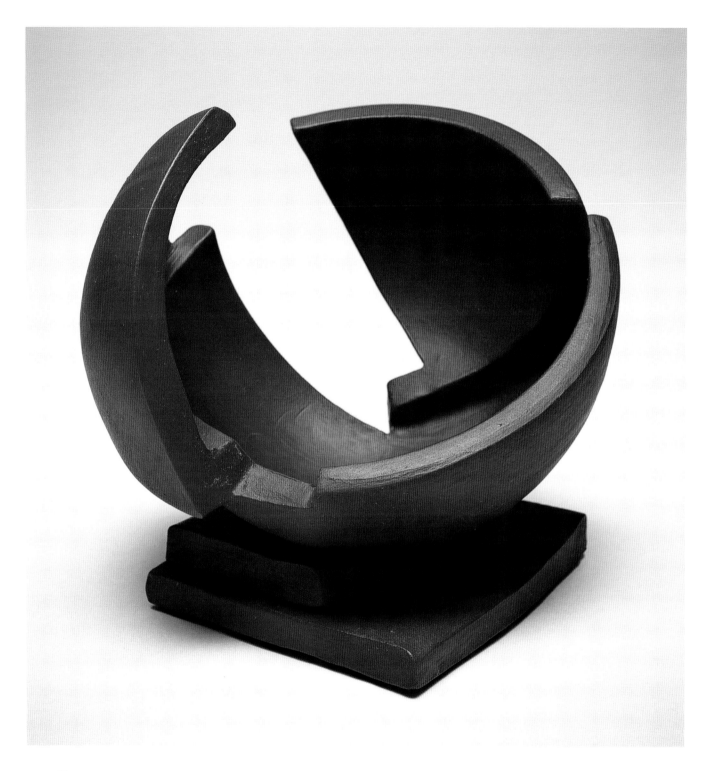

37

Remember, 2008

Painted stoneware

4½ × 5¼ × 4½ in.

Collection of Alison Stamey

38

Remember II 2, 2009

Prismacolor and graphite on layered tracing paper

10¼ × 10¼ in. image size

Collection of Joy Harvey and Frank Hoffman

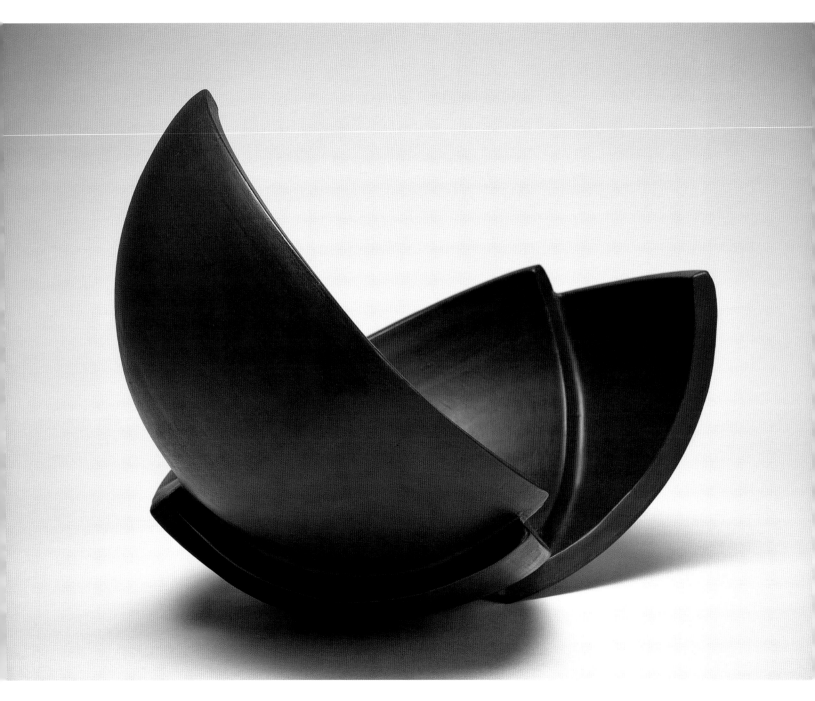

39

Reach, 2008

Painted stoneware

8½ × 11 × 8½ in.

Courtesy of the artist

and Francine Seders Gallery

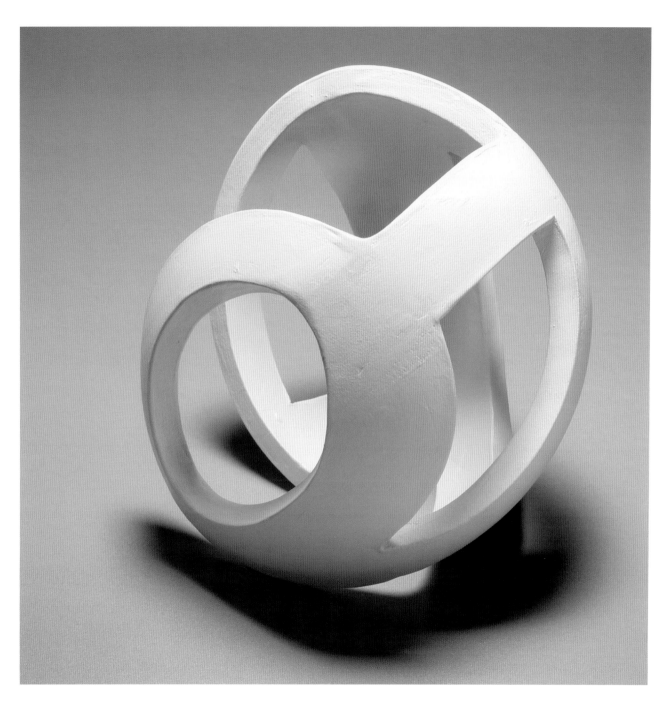

40

Re: Form 1, 2010

Painted stoneware

4½ × 4½ × 4½ in.

Collection of Annette Bellamy

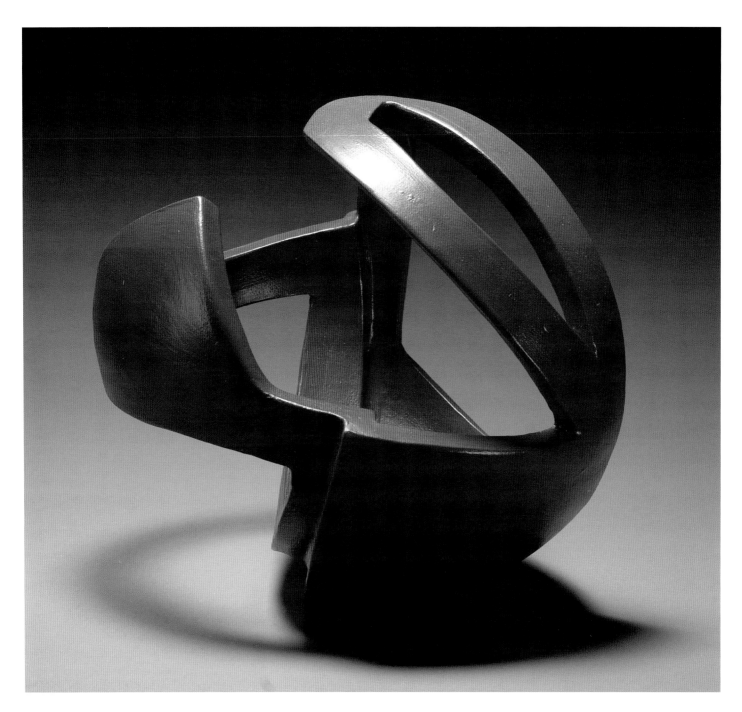

41

Re: Form 6, 2010

Painted stoneware

5½ × 6½ × 6½ in.

Private collection

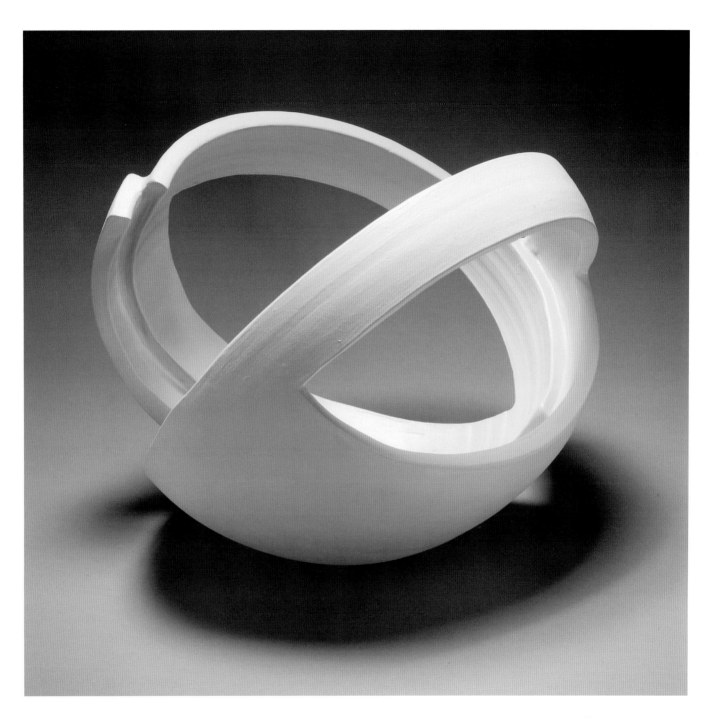

42

Re: Form 8, 2010
Painted stoneware
6½ × 7¾ × 8¼ in.
Private collection

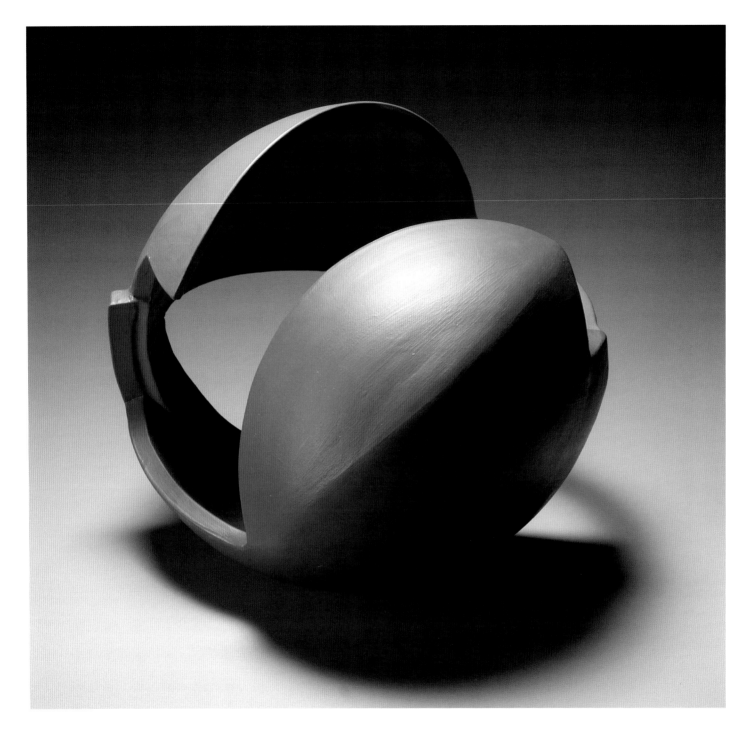

43

Re: Form 9, 2010

Painted stoneware

6¾ × 8 × 8 in.

Collection of Anthony Prud'homme

and Peter Boeschenstein

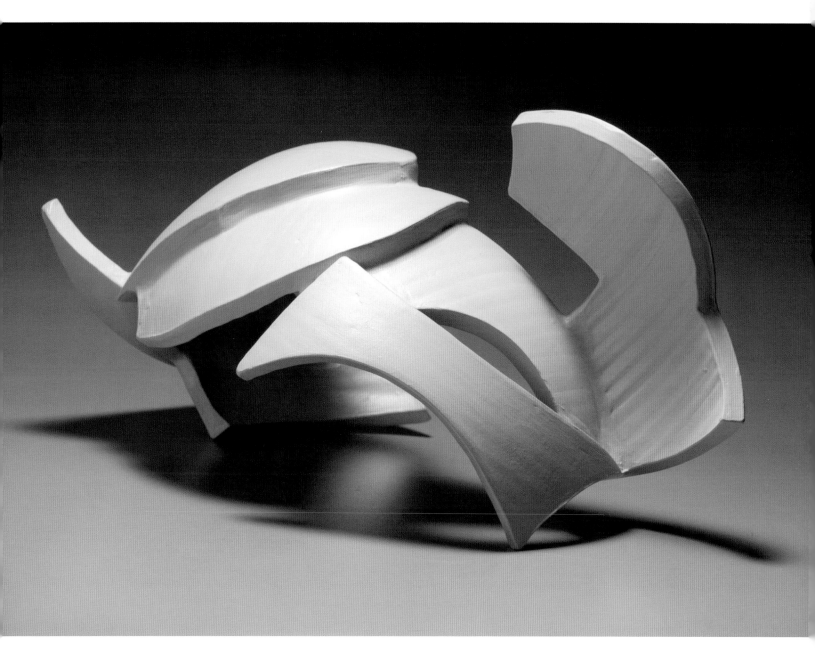

44

Extrapolation 3, 2010
Painted stoneware
7 × 14½ × 8½ in.
Courtesy of the artist
and Francine Seders Gallery

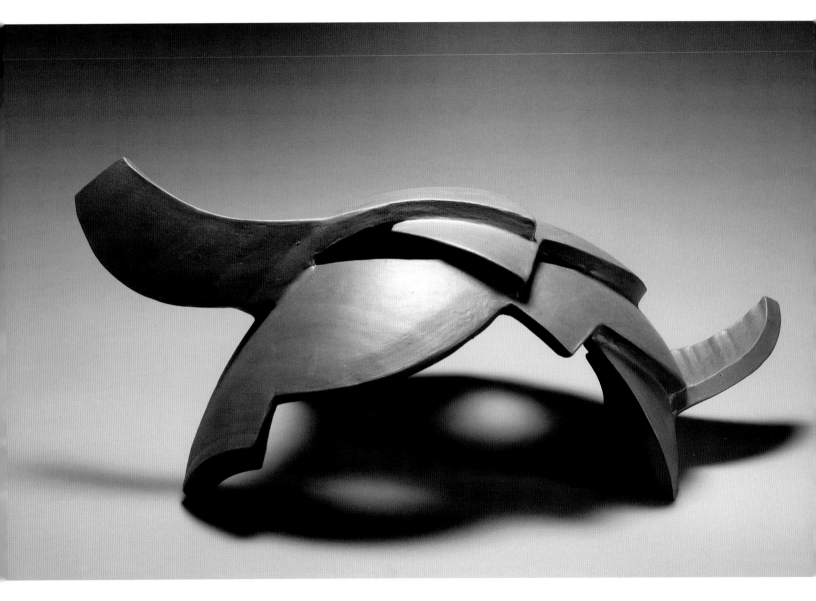

45

Extrapolation 6, 2010

Painted stoneware

5¾ × 15 × 9½ in.

Courtesy of the artist

and Francine Seders Gallery

46

Re:Coil 2, 2010
Painted stoneware
14¼ × 18 × 12 in.
Courtesy of the artist
and Francine Seders Gallery

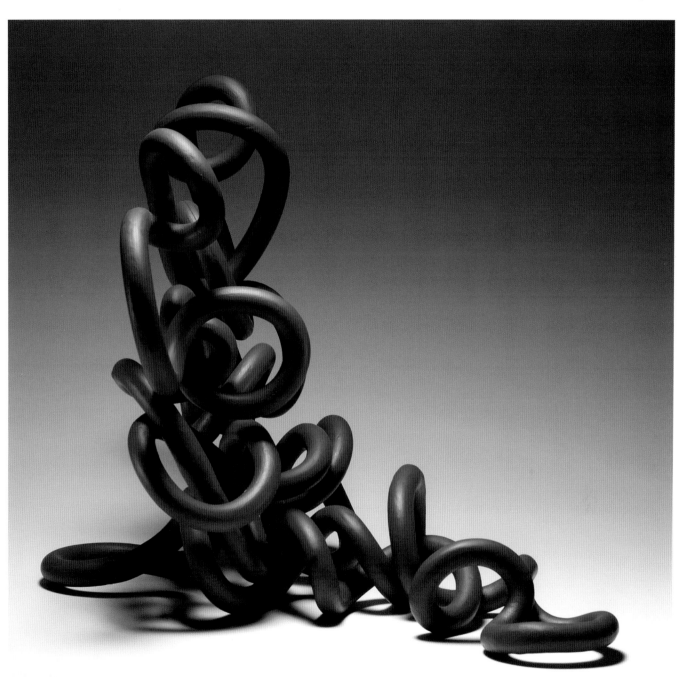

47

Re: Coil III, 2011

Prismacolor and graphite on layered tracing paper

16 × 16 in. image size

Courtesy of the artist

and Francine Seders Gallery

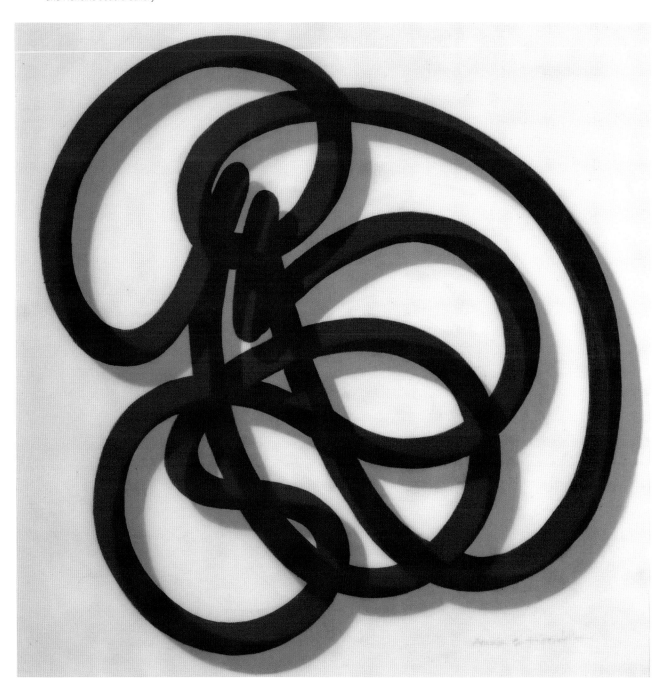

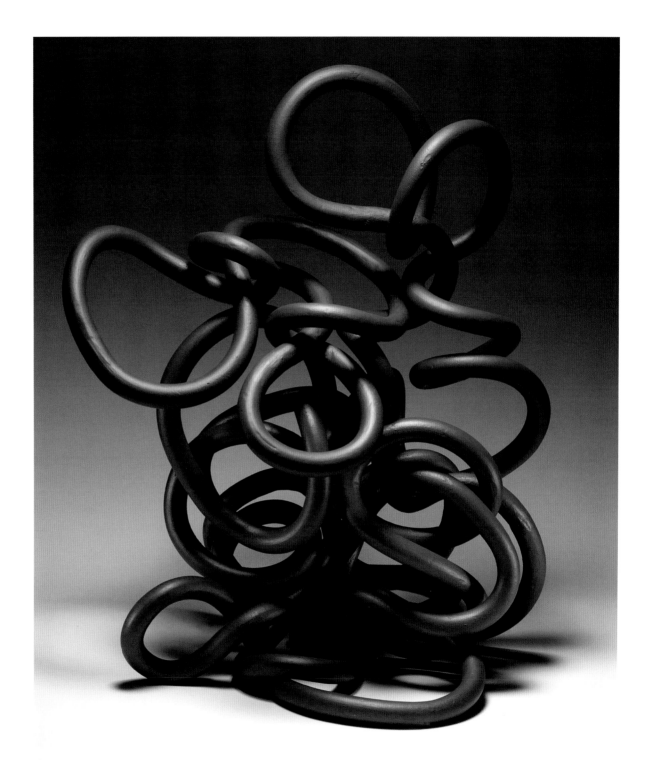

48

Re: Coil 7, 2010
Painted stoneware
18½ × 15½ × 12½ in.
Courtesy of the artist
and Francine Seders Gallery

Jake Seniuk

The Space Within, The Space Without

Anne Hirondelle opened another solo show at Seattle's venerable Foster/White Gallery on the first Thursday in September 2001. The classically inspired forms of her stoneware vessels infused the room with an air of antiquity while her reductivist tendencies spoke modernism. As always, the sleek ewers and buxom amphorae, for which she had gained wide acclaim over the preceding two decades, exerted a regal presence. Their mottled ash glazes glimmered with an oxidized metallic sheen reminiscent of ancient patinas, as if they were stately vessels unearthed from some ruin of the Bronze Age.

Trained on the potter's wheel at the beginning of her life in clay, Hirondelle has carried on a long engagement with the hand-thrown vessel. She recognized early on that the earthen pot, in all of its iterations, spans the whole of human history. Pots, urns, and vases have been purveyors of life and death—cradling food and drink, ablutions and discharges, medicines and poisons, the ashes of ancestors and aborted fetuses. Clay walls and interior voids echo the structure of the body itself, with its juxtaposition of solids and liquids. The omnipresence of bowls and pitchers in human activity links our past to the present. The elemental role of containers in daily life links our present to the future.

That spirit of endurance permeates Hirondelle's classic period. The ceremoniousness of her vessels from the 1980s and 1990s owes a great deal to the archetypal clarity of her forms, apt to conjure the genteel rituals of the tea ceremony as well as the whispered legacy of the crematorium.

Above all else, these are sculptures—aesthetic objects that have left the service tray and ascended the pedestal. An aura of intent and discipline clings to Hirondelle's exquisitely controlled forms. Many are a bit oversized, making their liquid-laden weight

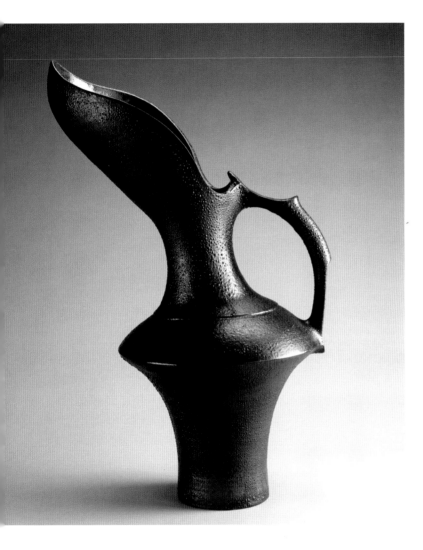

ity. Pinched funnels and rolled edges are drawn with labial lines that speak wordlessly about fertility.

Often Hirondelle creates her vessels in pairs of closely matched silhouettes posed in reflected postures, mimicking a courtship dance. These are conjugal tableaux, as formal as the marzipan figures atop a wedding cake. Above all, there is a sense of balance that rises from the centrifugal action of the potter's wheel itself.

As she left the Foster/White opening that Thursday night in 2001, Hirondelle felt the plate tectonics of her clay world begin to shift. She wondered if this might be her last show of classical vessels. Perhaps she had jarred the heated altruism of her youth within these lidded containers until it was now well seasoned. And, like a roused genie, it was clamoring for release.

She was ready to trade symmetry for syncopation, earthen shades for acid colors. And the zeitgeist of the new century was poised to emerge in the new directions her work was to take.

Port Townsend's strategic location on Admiralty Inlet, where the Juan de Fuca Strait opens into Puget Sound, has attracted both visionaries and patriots. The city was an early center of the shipping trade; its windswept bluffs were once host to battlements against an invasion that never came. Forts Worden, Flagler, Townsend, and Casey are now historical state parks that host an array of cultural and educational programs—music festivals and artists' residencies, workshops and retreats, culture camps for the outward bound.

The town's hills are generously sprinkled with gingerbread Victorians, the grandest of which are periodically recycled as picture-book bed-and-breakfasts. The narrow downtown is squeezed against the base of tall bluffs and strung out along Water Street, which on weekends and in the summer streams with tourists browsing its bookstores, restaurants, and boutiques.

impractical for anyone who is not larger than life. They are clearly objects of reflection. But what is it that's reflected?

The female form—the vessel of life—is in the background as an inspiration. So is the garden. The symmetry of Hirondelle's wheel-spun vessels seems to grow upward toward the light. The purity of the shape is unadorned, except for hand-built handles and spouts that sprout like limbs from the trunk's sensuous solid-

Fig 10 *Conjugal Pitcher Diptych,* 1986

Glazed stoneware with lacquered base

12 × 24½ × 7 in.

Private collection

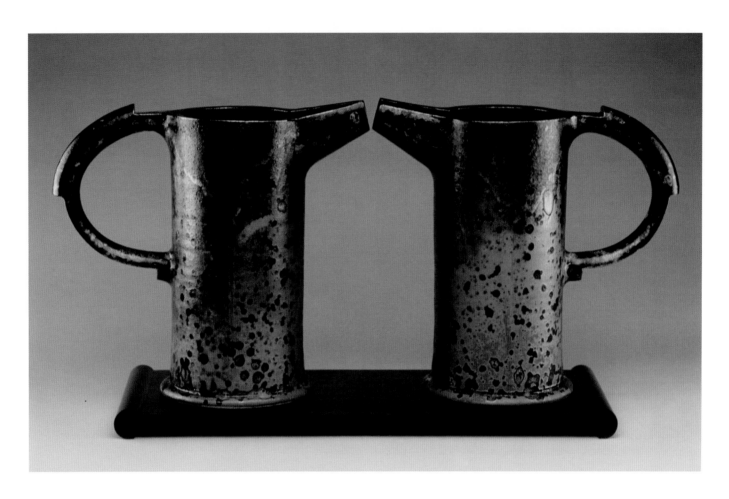

When the new railroads found their terminus on the eastern shores of the Sound, Port Townsend ceded to Seattle its intended destiny as the future metropolis of the Pacific Northwest. It has instead evolved into a ferry-moated, Victorian-faced haven for the independent minded. There is an open feeling to the neighborhoods, where sidewalks and fences are rare and idiosyncratic; hand-built and hand-rebuilt homes—separated by garden plots and backyard orchards—are common. Many residences have outbuildings devoted to cultivated passions, ranging from wooden boatbuilding to orchid propagation.

Anne Hirondelle and her husband, Bob Schwiesow, found a niche in Port Townsend in a turn-of-the-century cottage on a large lot, where they have for more than thirty years built a spare life around Hirondelle's clay practice and their perennial garden. Hirondelle's studio is little more than a dozen steps from the kitchen porch, but it serves as the locus of a disciplined daily practice of making art. Hand built by Schwiesow and family friend Walt Engel from a design by architect Jim Cutler (with whom Hirondelle traded two of her sculptures), it is a light-filled well of simplicity and order. Its monkish, elemental quality

Fig 11 Anne Hirondelle's studio, 2007

makes it a provocative bookend to another Cutler design for a different sort of family compound, Bill Gates's micro-Xanadu on Lake Washington.

Here, surrounded by tidy shelves displaying natural objects from which she derives inspiration, and with her gardens framed in the window, Hirondelle sketches and designs, observes the play of light on greenware, and contemplates what's inside and outside in both physical and philosophical spheres.

Anne is petite and reserved, with a temperament of calm deliberation, observed in voice and movement. She took the name

Hirondelle, French for swallow, as a totemic link to the sharp-winged cliff-nesters whose compact strength and fearless aerobatics she admires. With her chiseled mane (she styles the hair of artist friends as an avocation) and in her clay-streaked uniform of denim and T-shirt, one senses the aura of some muse-driven artistic yogi at work, ready to plumb the essence of shaping clay.

That essence might be found in the earth itself, which is at the root of her need and passion for the garden. Over the decades, and in tandem with the sculptural evolution of her clay forms, she has cultivated what began as bare fields into an oasis of green

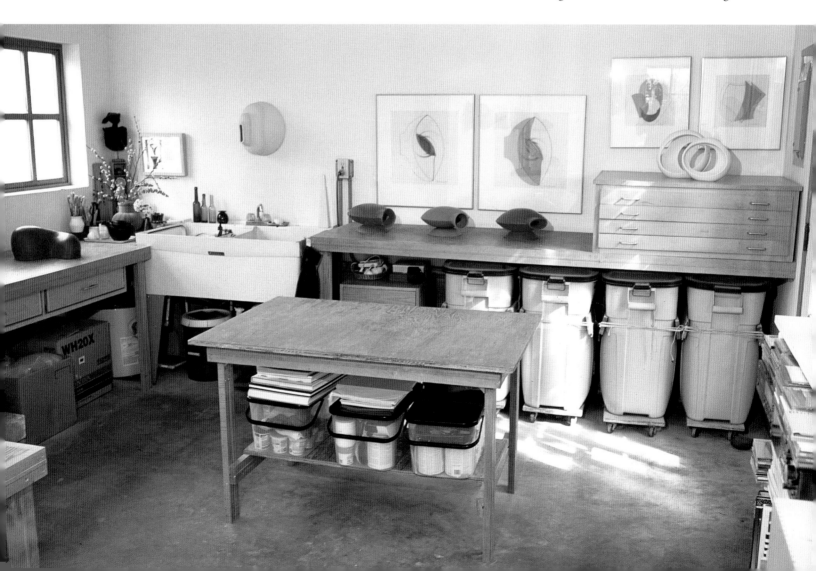

Fig 12 Anne Hirondelle's garden, 2000

rooms that include a welcome garden, a contemplation garden, a petite orchard, and a communion area.

Citing poet Stanley Kunitz, Hirondelle confesses, "Gardening for me is the passionate effort to organize a little corner of the earth, which I want to redeem . . . to achieve control over your little plot so that it appears beautiful, distinguished—an equivalent of your signature in the natural world."[1]

As both gardener and artist, Anne Hirondelle has achieved success through implementing a strategy of limitation, both by reducing the number of her choices and by maximizing her control over the possibilities. In her sanctuary of art and earth, she has found that one possibility leads to the next like the passage of the seasons.

Holding on, letting go . . . Those four words—which, like a zen koan, speak truth through seeming contradiction—have become Hirondelle's mantra as she walks the paths of her days. Anne met the twenty-first century head on by first abandoning, then eventually exploding, the vessel form she had so revered and fastidiously explored.

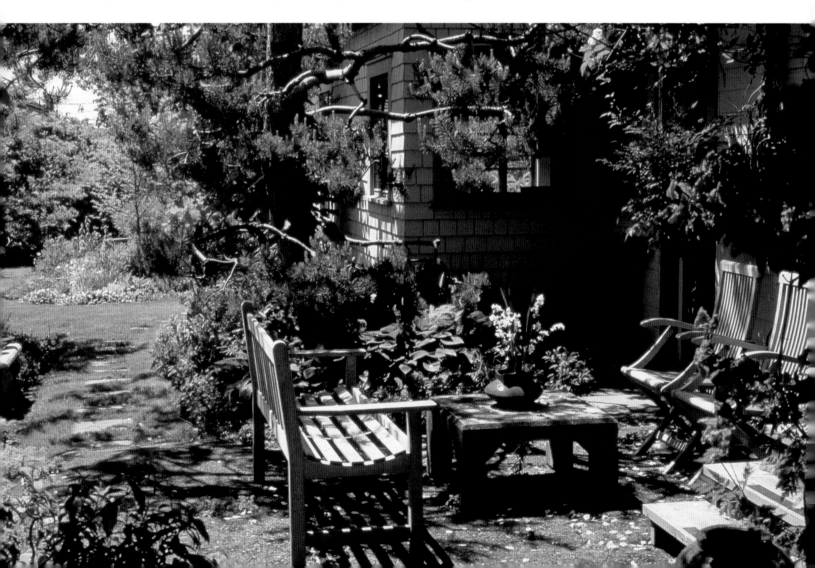

Not long after her Foster/White show in 2001, she premiered her series *Outurns* (plates 24 and 26), which sprang from the pedestal to the wall and, as promised in the title, began a topological quest to turn the urn inside out. There is a hint of Mobius about this work, like a partially reversed stocking en route to the wash. Whereas her earlier vessels had sought metaphors within past traditions, these mutating containers are improvisational—unglazed and unabashedly organic, and erupt from the wall like hungry gastropods. At the same time they seem inhabited by consciousness, recalling the spirit masks of Papuan mudmen, each given personality by the distinct expression of a central, maw-like vacuole.

In her *Go* series of 2005 (plates 27 and 28), Hirondelle *sliced* the urn apart into tubular cross-sections, great filo rounds of smooth slab clay that fold back onto themselves. Having abandoned her soda-ash glazes in the *Outurns* to focus firmly on form, she was now ready to bring color back into play. Using a buttery mixture of artist's acrylic pigments and latex house paint, she slathered the chalky curls with juicy coats of cadmium red and orange, lapis blue, wasabi green, and chrome yellow.

When these works were grouped into concentric nested families, she called them *Tumbles* (plates 31 and 32), and indeed they share a windblown rhythm with the western tumbleweed. Against this randomness of motion she assigns each ring one of a suite of stabilizing colors, creating intervals of chromatic harmony that are the eye's equivalent of musical chords.

Hirondelle has always been acutely conscious of negative space, using line and contour, and now color, to frame what *isn't* there and thus activate what *is*. The matched silhouettes and contained volumes of her classic vessels have often been described as architectural. With these pieces, her work now began to engage real architecture—the space in which the art is seen—in a more expansive way.

Three dozen of her *Go Pillows* hang on the wall in a grid, like the enlarged pebbles of the Chinese board game Go. The hidden backside of each work has been painted so that color reflects mutedly onto the wall behind, a low-wattage glow casting a feathery pillow for each alabaster sphere to nest upon. They might be spores or seedpods, simple shells that divide what's within from what's without, what *is* from what is possible. The nearly identical rows and columns imply an endless matrix, and the mind extrapolates their atomic pointillism in all directions.

The bowl is the primary clay object, the original hemispheric form from which all ceramics multiply. In her later work, Hirondelle has cut the bowl apart and deconstructed the vessel to its essentials.

The *Re:Form* series (plates 40, 41, 42, and 43) presents cutaway views through the orb, stripping the bowl of its solidity and power to contain while retaining strategic arcs and vectors that speak to alternate stages of evolution. With the *Remember* series (plate 37), Hirondelle slices the sloping walls into a shipwreck of jagged shards and then reassembles them into études of disintegration. Mounted as a grid of variations (plates 35 and 36), each becomes a fixed point in the crash, like a Muybridge stop-action photograph showing the successive hoof positions of a trotting horse.

With the *Re:Coil* series (plates 46 and 48), she antedates the potter's wheel and uses only hand-extruded coils, long snakes of rolled clay that twist and turn, rise and genuflect to form an airy mass that can be both freestanding or wall-hung. The seemingly endless coils writhe like vapor trails, or root and burrow like a tunnel of worm castings.

In her earlier earthtone vessels, Hirondelle had perused Adam's clay like a collector of myths and tales. Now, her polymer-skinned improvisations on underlying form feel closer to physics

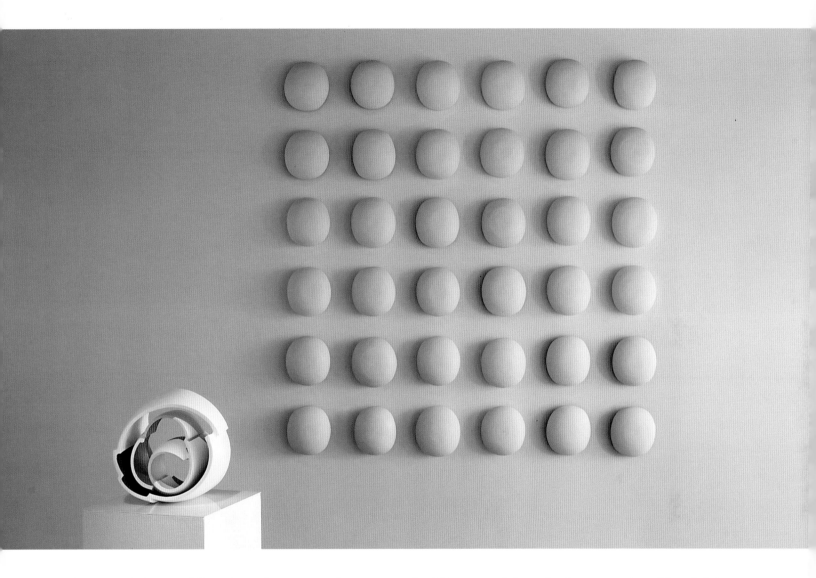

than to mythology. To fully embrace the enigmas of time, one must find a spot from which to observe the struggle between the past and the future while staying fully engaged in the present. In her life's corpus of clay and in her person, Anne Hirondelle has achieved a fine-tuned balance of soul and mind that is evident in every work that leaves her hands.

1 Valerie Easton, David Laskin, and Allan Mandell, *Artists in Their Gardens* (Seattle: Sasquatch Books, 2001), 35.

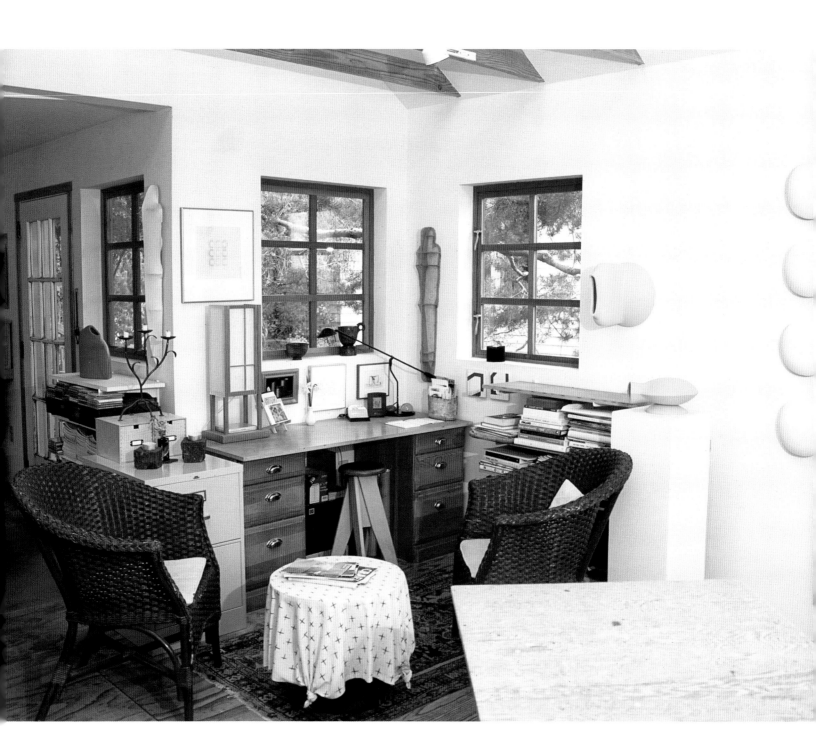

ABOUT THE ARTIST

Anne Hirondelle was born in Vancouver, Washington, in 1944 and spent her childhood as a farm girl near Salem, Oregon. She received a BA in English from the University of Puget Sound (1966) and an MA in counseling from Stanford University (1967). Hirondelle moved to Seattle in 1967 and directed the University YWCA until 1972. She attended the School of Law at the University of Washington for a year before discovering and pursuing her true profession, first in the ceramics program at the Factory of Visual Arts in Seattle (1973–74), and later in the BFA program at the University of Washington (1974–76). Anne Hirondelle has lived and worked in Port Townsend, Washington, since 1977.

During her thirty-year career Hirondelle has produced numerous bodies of work that have been exhibited in one-person shows. She has worked with many galleries throughout the United States and has had multiple solo exhibitions with:

Foster/White Gallery, Seattle (1986–2001)

Garth Clark Gallery in New York, Los Angeles, and Kansas City (1987–95)

Snyderman-Works Galleries in Philadelphia (1991–2004)

Joanne Rapp Gallery/The Hand and the Spirit in Scottsdale (1991–96)

Francine Seders Gallery, Seattle (2003–11)

Many independent and museum curators have featured or included Anne Hirondelle's work in their exhibitions. The following shows were of special significance to her career:

The Vase and Beyond: The Sidney Swidler Collection of Ceramics, Crocker Art Museum, Sacramento, California (2010–11)

Guy Anderson and Other Friends: The Paul I. Gingrich, Jr. Collection, Museum of Northwest Art, La Conner, Washington (2010)

Show of Hands: Northwest Women Artists 1890–2010, Whatcom Museum, Bellingham, Washington (2010)

Outurn, Abouturn and Go, Port Angeles Fine Arts Center, Port Angeles, Washington (2007, solo show)

Innovation and Change: Great Ceramics from the ASU Art Museum Collection, Tempe, Arizona; traveling exhibition (2008–10)

Standing Room Only: The 60th Scripps Ceramic Annual, Ruth Chandler Williamson Gallery, Scripps College, Claremont, California (2004; also *43rd Scripps Ceramic Annual*, 1987)

Five Part Invention, Museum of Northwest Art, La Conner (2003)

Great Pots: Contemporary Ceramics from Function to Fantasy, Newark Museum, Newark, New Jersey (2003)

Viewing Program and Registry, The Drawing Center, New York, New York (2002)

International Teapot Exhibition, Yingko Ceramics Museum, Taipei County, Taiwan (2002)

Color and Fire: Defining Moments in Studio Ceramics, 1950–2000, a traveling exhibition curated by Jo Lauria, Los Angeles County Museum of Art, Los Angeles, California (2000)

Exploring a Movement: Feminist Visions in Clay, curated by Jo Lauria; multisite exhibition, Los Angeles (1995)

The White House Collection of American Crafts, National Museum of American Art, Washington, DC (1995; exhibition traveled 1995–2004)

From Our Vault to the Studio: New Work by Craft Artists in the Wustum Collection, Racine Art Museum, Racine, Wisconsin (1993)

28th Ceramic National Exhibition, Everson Museum of Art, Syracuse, New York (1990)

Northwest Ceramics Today, Survey of Northwest Ceramic Artists, Nora Eccles Harrison Museum of Art, Utah State University, Logan, Utah (1989)

Women in Washington: The First Century, Wekell Gallery, Pacific Lutheran University, Tacoma, Washington; juried, First Place Award (1989)

Embellishment beyond Function, Invitational, Henry Art Gallery, University of Washington, Seattle, Washington (1981)

Crafts '80, Tacoma Art Museum, Tacoma; juried, Third Place Award (1980)

Anne Hirondelle has frequently interrupted her studio practice to teach, lecture, and work as an artist in residence. The give-and-take of conversation with students and colleagues has helped clarify her thinking about her craft and offered others the opportunity to learn from her skill and experience. Hirondelle has lectured and/or taught workshops at these institutions, among others:

Haystack Mountain School of Crafts, Deer Isle, Maine (2008, 2000)

Seward Park Clay Studio, Seattle, Washington (2005, 2000, 1990, 1988)

Penland School of Crafts, Penland, North Carolina (2005)

Emily Carr School of Art and Design, Vancouver, BC, Canada (2004, 1990)

Greenwich House Pottery, New York, New York (2004)

Yingko Ceramics Museum, Taipei County, Taiwan (2002)

Arrowmont School of Arts and Crafts, Gatlinburg, Tennessee (2001, 1996, 1993)

Arizona State University, Tempe, Arizona (1999, 1996, 1993)

Anderson Ranch Arts Center, Snowmass Village, Colorado (1993)

Gardiner Museum of Ceramic Art, Toronto, Ontario (1991)

The Northwest arts community recognized Hirondelle's accomplishments with the 2009 Irving and Yvonne Twining Humber Award for Lifetime Artistic Achievement; she was also a finalist for the 2004 Seattle Art Museum's Betty Bowen Award. She received a National Endowment for the Arts Visual Artist Fellowship in 1988.

Selected Public Collections

ASU Art Museum, Arizona State University, Tempe, Arizona

Arkansas Arts Center, Little Rock, Arkansas

Arrowmont School of Arts and Crafts, Gatlinburg, Tennessee

Boeing Corporate Headquarters, Chicago, Illinois

Boise State University, Boise, Idaho

Iris & B. Gerald Cantor Center for Visual Arts, Stanford University, Stanford, California

Crocker Art Museum, Sacramento, California

Fine Arts Museums of San Francisco, San Francisco, California

Gateway Tower, Seattle, Washington

Hallmark Cards, Kansas City, Missouri

Harborview Medical Center, Seattle (The Contemporary Northwest Ceramics Collection, Norm Maleng Building)

Howard and Gwen Laurie Smits Collection, Los Angeles County Museum of Art, Los Angeles, California

JMB Realty Corporation, Chicago, Illinois

Long Beach Museum of Art, Long Beach, California

Museum of Arts and Design, New York, New York

Museum of Northwest Art, La Conner, Washington

Neiman Marcus, Bellevue, Washington

Newark Museum, Newark, New Jersey

Nora Eccles Harrison Museum of Art, Utah State University, Logan, Utah

Oregon Arts Commission, Percent for Art Collection, Salem, Oregon

Pacific Lutheran University, Tacoma, Washington

Racine Art Museum, Racine, Wisconsin

Marer Collection, Ruth Chandler Williamson Gallery, Scripps College, Claremont, California

Seattle Public Utilities 1% for Art Portable Works Collection, Seattle

Tacoma Art Museum, Tacoma, Washington

University of Iowa Museum of Art, Iowa City, Iowa

Walker Art Collection, Garnett, Kansas

West One Bancorp, Boise, Idaho

Westwood Corporation, Portland, Oregon

Whatcom Museum, Bellingham, Washington

White House Collection, William J. Clinton Library, Little Rock, Arkansas

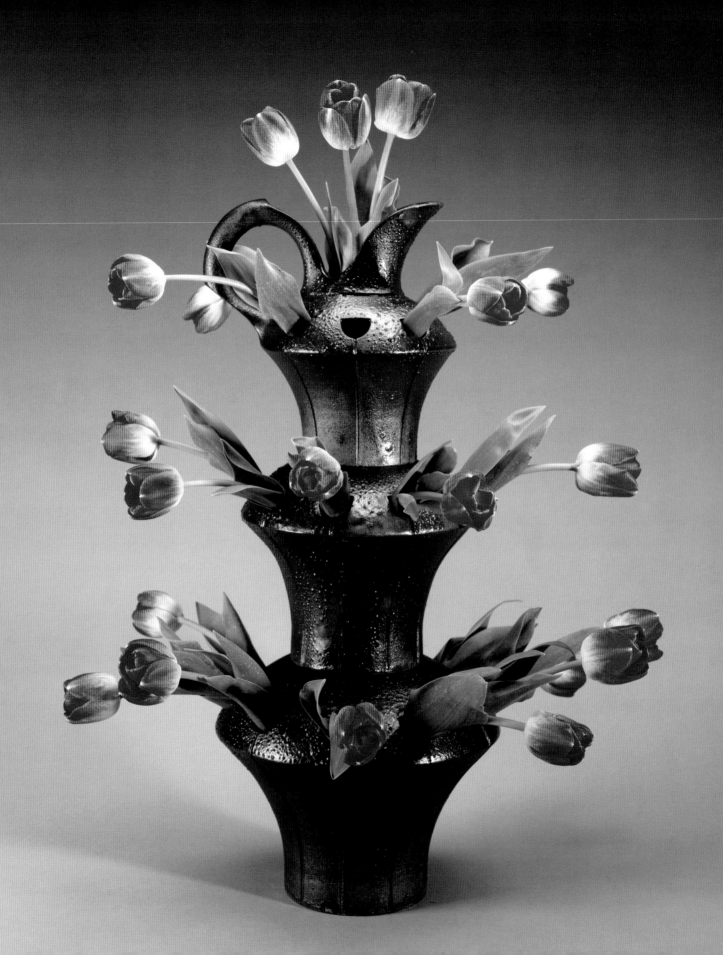

PATRONS

Margie Abraham

Dina and Yoram Barzel

Charlotte W. Baxter

Annette E. Bellamy

Marcella W. Benditt

Sanford M. Besser

Shirley and Alf Collins

Jonathan and Jennifer Coney

Mary Coney

Julie Coryell

Paul and Sharon Dauer

David R. and Jane Davis

Charles R. Draney

Thelma Fite

Darcy and Steven Franceschina

Carole J. Fuller and Evan Schwab

Paul I. Gingrich Jr.

Gene and Lois Graham

David Griswold and Kimberly Kopp

Jim L. Hanson

Joy F. Harvey

Sandy Marie Harvey

Frank C. Hoffman

R. J. Hull

David and Gail Karges

Jack and Layne Kleinart

Mary Jane Knecht

Greg Kucera Gallery

Maggie and Mark Mosholder

Grace Nordhoff and J. R. Beard

Patricia Overy

Sally and Art Pasette

Miriam V. W. Pierce

Margaret Nora Porter

Robert Schwiesow

Francine Seders Gallery

Fred Simons

Pat Soden and Marilyn Trueblood

Leroy and Joie Soper

Alison Stamey and Twig Mills

David Stobaugh and Lynn Prunhuber

Tree Swenson

Michael J. Swindling

Jerry and Ernalee Thonn

Uptown Dental Clinic

M. Patricia Warashina

Kathie A. Werner

Paul G. Wilson

Thomas T. Wilson

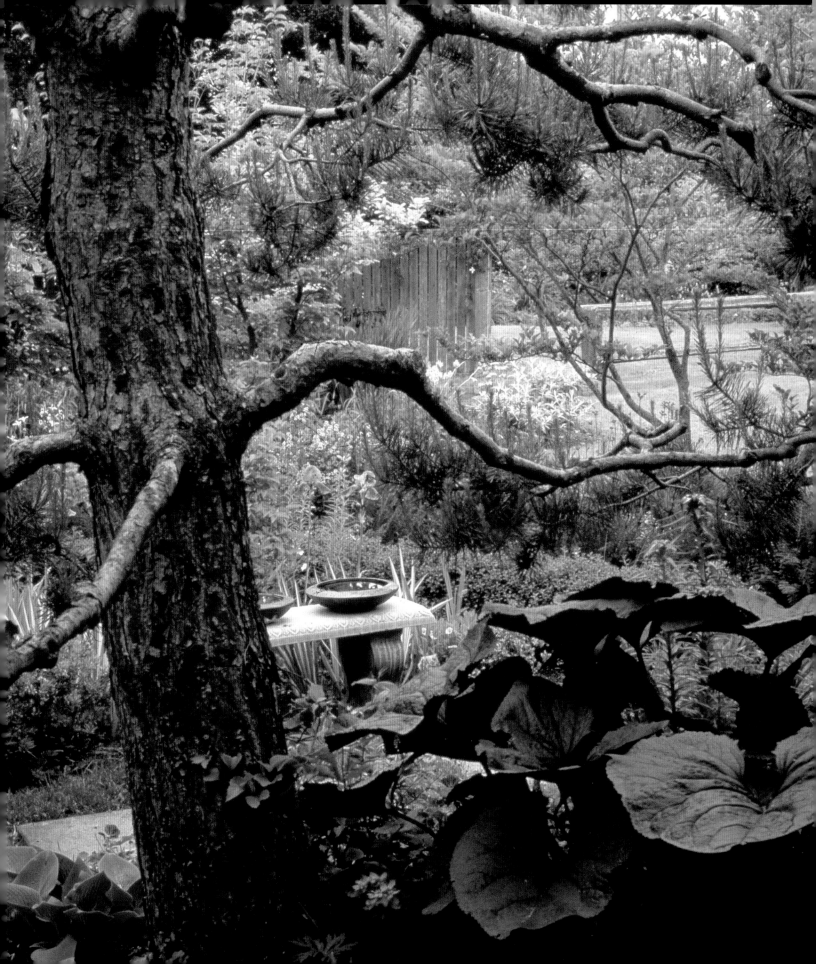

PHOTO CREDITS

M. Lee Fatherree: plate 1

Myron Gauger/Artshots: figs. 5, 8; plates 22, 32, 40–48

Russell Johnson: plate 30

Allan Mandell: fig. 12; p. 80

Sam Parsons: plate 8

Frank Ross: frontispiece; figs. 1, 6–7, 11; plates 24–29, 31, 33–39; pp. 2, 6, 66, 74

Roger Schreiber: figs. 2–4, 9–10; plates 2–7, 9–21; pp. 16, 78

Jake Seniuk: fig. 13

Rod Slemmons: plate 23

Terri Stoneburner: p. vi